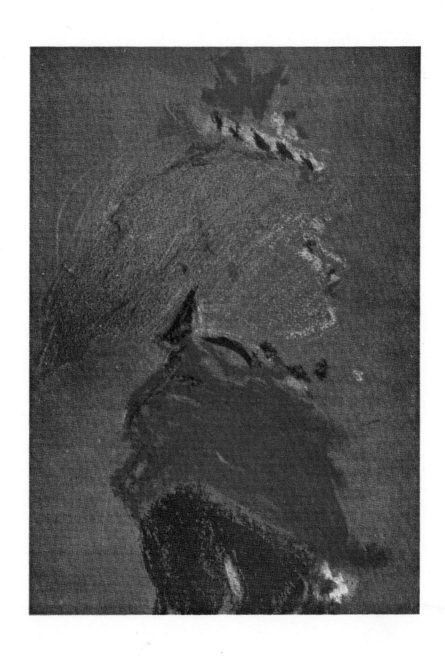

ADA LUNDBERG

THE
EARLY WORK
OF
AUBREY
BEARDSLEY

WITH A PREFATORY NOTE BY H. C. MARILLIER

DOVER PUBLICATIONS, INC., NEW YORK

This Dover edition, first published in 1967, is an unabridged republication of the revised 1920 edition of the work originally published by John Lane, The Bodley Head. The present edition differs in the following respects:

The two plates printed in color in earlier editions (there was no color in the 1920) are reproduced here in color, in addition to their black-and-white reproductions in the 1920 numerical sequence.

The frontispiece and title-page frame of the original editions now appear in their proper numerical sequence as Plates 1 and 2.

The reproductions in this volume have been made from the best available editions or collections of Beardsley's work.

International Standard Book Number: 0-486-21816-3
Library of Congress Catalog Card Number: 67-21705

MANUFACTURED IN THE UNITED STATES OF AMERICA

DOVER PUBLICATIONS, INC.
180 VARICK STREET
NEW YORK, N.Y. 10014

LIST OF PLATES

LIST OF PLATES

* Also in color between Plates 4 and 5.

LIST OF PLATES

LIST OF PLATES

* Also in color as the frontispiece.

LIST OF PLATES

PUBLISHER'S NOTE

THERE has been considerable rearrangement of the plates. Many that originally appeared in the " Later Work " are now transferred to this volume, and conversely, in order to preserve a proper chronological sequence.

Aubrey Vincent Beardsley

Born August 24, 1872—Died March 16, 1898

ONE hears it asserted, with a confidence that possibly may be born of a wish, that " the Beardsley craze is dead." For such as truly hold this belief it can never have been very much alive ; nor is there reason why it should have been. The suddenness of Beardsley's leap into notoriety, the curiosity excited by his audacious invention and novel style, the puzzlement that his work produced on the minds of a steady-going public, sensitive to shocks, are sufficient justification in themselves for those who can see in him only a transient " craze." Beardsley never could have been, and never was, intended for the many. His work is seldom of a kind that could be described as popular. Much of it, indeed, is so deliberately regardless of popular prejudices and conventions that one cannot wonder if the public at large found voice to protest against the effronteries of Beardsley at large, and objected to the inroads made upon their forbearance by what they could only regard as incomprehensible manifestations of an unmentionable phase of life.

Making all possible allowance for this attitude, however, it remains a truism that objections do not kill. To a young and rising artist they are as wholesome nutriment as praise ; frequently more wholesome. And Beardsley had both. Extravagantly praised and extravagantly hated, he worked in an atmosphere of exotic stimulus which was largely responsible for the eccentricities that developed themselves in his art and in his character. Pricked on upon one hand by the lavish admiration of a group which saw

in him more genius than he was really conscious of himself, piqued on the other by the exclamations of a public he was delighted to offend, it is small wonder that his work presented a seesaw appearance, ranging from the nearly sublime to the more than frankly ridiculous. It is this variability, coupled with an extraordinary versatility for changing his style and adopting new ones, that makes it difficult to estimate the true position of Beardsley in the pantheon of art. There are some points, such as the exquisite quality of his drawing, on which all critics are agreed ; there are still more on which no two of them can think alike. Yet, however much we agree or however much we differ in our estimation of his work, one thing at least must be said in reply to those who are so confident of his extermination —viz. that to speak of Beardsley as " dead " in any but the mere physical sense, which those who knew him best have most cause to deplore, is an error against Truth as well as against the facts. We may leave Truth to take care of herself. Time and art will vindicate her. But as regards facts, which are often a different thing, it may be necessary to point out that the demand for Beardsley's work, which in his lifetime was satisfied by a few monthly instalments in certain recognized periodicals, and a sporadic sprinkling of casual contributions besides, has grown within the last few months, since his death, so much as to call for three distinct collections, of which the present is the largest in size, as well as, from some points of view, the most important in scope and interest.

The Beardsley " craze," indeed—if " craze " there be—is really just beginning. Those who could appreciate the sterling qualities of his work have already done so, and have probably collected for themselves the scattered outpourings (and occasional off-scourings) of his imagination, marred, as they too often were, by faults of printing or of reproduction. It would be interesting to know how many such collections exist, as they would probably afford some insight into the number of Beardsley's genuine ad-

mirers, whose admiration enabled him to thrive. The sumptuous compilations which we are now considering betoken a different public altogether, or at the least a renewed curiosity which requires to be pampered. It is in such passive admiration that there lie the makings of a " craze." Not that any one need be less inclined on that account to welcome the re-appearance of Beardsley's masterpieces, decently printed, with suitable margins, and in many cases shown for the first time on a scale calculated to do justice to the subtle fineness of the artist's inimitable line-work. Nor will the faithful, I imagine, have cause for regret, seeing themselves enriched at one swoop by the acquisition of very many drawings now difficult to obtain in the form in which they originally appeared, and of not a few others which but for the opportunity thus afforded would never have been published at all. Educationally, moreover, these books should have some value, not necessarily as showing the public what they ought to admire, for each generation will have its own views on this point, but as summarizing in a convenient form for reference a phase of art which is extremely interesting in itself, and which has exerted an influence over contemporary artists quite out of proportion to its quantity, to the age and standing of its author, and to the dignity of the subjects with which it treats. It is significant that, although Beardsley has had numerous imitators on both sides of the Atlantic, in his own particular line of work he has remained without a rival. He is not only the inventor, but *par excellence* the master, of his methods. How, except by a freak of nature, so marvellous an intuition and so perfect a mastery of style ever fell to the lot of an untrained boyish hand, we can never tell. Minerva-like, Aubrey Beardsley seems to have come into the world ready equipped with genius and the power of execution, and so must take his place amongst the rapidly growing ranks of *Wunderkinder*. There is something in the age which tends towards the specialization of children. Musical prodigies have almost ceased to

attract attention, so numerous have they become ; and, although precocity in art is rarer than in music, we have at least one classical instance in Oliver Madox Brown, and we see the two little Detmolds exhibiting year after year, alongside adult work, pictures of matured expression and technique. Beardsley was not so precocious as this. His schoolboy drawings, of which several specimens appeared in *Past and Present*, the magazine of the Brighton Grammar School, are as healthily crude and jejune as any one could desire. It was not until he was eighteen or nineteen, an age when most artists are content to be grinding at the student mill, that Aubrey Beardsley (skipping studenthood) came forward with the drawings that at once began to make him famous. In the short six years of his artistic life, years quite unvaried by adventure, and curtailed by a ravaging disease that periodically incapacitated him from working, there are few incidents that have not already been noted. It is going over old ground to relate how Mr. Joseph Pennell, whose discoveries of latent art in England are amongst the triumphs of critical exploration, also discovered Beardsley, or at least gave him his first public notice, a glowing eulogy in the opening number of *The Studio* (April 1893), which was accompanied by reproductions of " The Birthday of Madame Cigale," the " Revenants de la Musique," " Siegfried," " Salome with John the Baptist's Head," and some drawings done for the " Morte d'Arthur." Beardsley at this time, when Mr. Pennell, like Cimabue, found him doing wonderful things with his hands, and exploited him, was in his twentieth year and, although not tending sheep as the parallel might suggest, was slaving at an uncongenial desk in an insurance office. Such drawings as he had were done in leisure hours for his own amusement. Of training he had had none, unless a brief experience of an architect's drawing office could count as such. But now, acting on the advice of Mr. (the late Sir Edward) Burne-Jones, and of M. Puvis de Chavannes, both of whom thought they saw in his early efforts the promise of a brave

recruit to the ranks of romantic illustrators, Beardsley abandoned business
and took to art as a profession, putting in for a time a desultory attendance
at the famous studio of Mr. Fred Brown. He had little difficulty in obtain-
ing work. Even before the appearance of Mr. Pennell's article in *The
Studio* he had, through the instrumentality of Mr. Frederick H. Evans,
always one of his warmest friends, entered into an undertaking to illustrate
the two-volume edition of Malory's " Morte d'Arthur " for Messrs. J. M.
Dent and Co., a task which might well have left him reasonably satisfied
and busy for some considerable time, but which, as events turned out,
proved a bitter thorn in the flesh. Beardsley, as most publishers who dealt
with him knew to their cost, was a curiously nervous and fickle creature.
If work pleased him, he was exultant and prompt with it ; if it bored him,
wild horses could scarcely get it from him. The most sacred engagements,
the loudest imprecations, failed to move him if they conflicted with his
humour at the moment, and, knowing what difficulty he had in bringing
himself to complete the promised drawings for the " Morte d'Arthur,"
one's only wonder is that so little falling off from his original standard
is visible in the second volume of the work. Had the drawings been done
in the order in which they appeared, the degradation, it is said, would have
been more apparent than it actually is. But, making all allowances, the
" Morte d'Arthur " illustrations are a wonderful accomplishment for a boy
of twenty. The amount of invention, to say nothing of the execution,
lavished upon the five hundred and forty-eight vignettes and decorative
borders, is prodigious, whilst some of the full-page and double-page pictures
show a power of composition and a daintiness of drawing that Beardsley
himself never improved upon and that no imitator has succeeded in cap-
turing. It is a pity, and it is one of the things which discouraged Beardsley
in the work, that the conditions of the book required a scale of reduction
in the illustrations which totally fails to do justice to the fine quality of his

drawing ; and those who seek to find Beardsley's work in the vignettes or ornaments of the " Morte d'Arthur " should supplement their search by turning up the later full-sized reproductions which have been made of some of them.

The " Morte d'Arthur " was not the only work which Beardsley produced, or on which he was engaged, before the appearance of the first number of *The Studio*. Mr. Lewis Hind, who had left *The Studio* to edit *The Pall Mall Budget*, and in this way knew of the young illustrator's talents, employed him on several occasions in a more or less topical capacity. The results can hardly be called happy. The drawings done to illustrate Irving's " Becket " and the performance of " Orpheus " at the Lyceum, together with one or two other subjects which the manager of *The Pall Mall Gazette* has allowed to be reprinted here, speak volumes for Beardsley's incapacity to adapt himself to a style of work requiring rapid execution and affording no play to the imagination. With the possible exception of the portraits of Zola, and the four humorous sketches for " The New Coinage," Beardsley's incursion into topical journalism was a failure, and was abandoned after a few attempts. It was otherwise with his two contributions to *The Pall Mall Magazine*, also reprinted here, one of which, the design published in the second number of the Magazine (June 1893) under the fictitious title of " A Neophyte, and how the Black Art was revealed unto him by the Fiend Asomuel," remains to this day one of his most powerful and decorative achievements.

Towards the end of 1893, or the beginning of 1894, Beardsley formed an idea of preparing what he called a Book of Masques, and he was very full of this amongst his friends. The scheme was abandoned, but revived later on, in a new shape, when it was proposed to start *The Yellow Book* as a quarterly magazine, with Beardsley as art editor. It is in *The Yellow Book*, more than anywhere else, that Beardsley first came into contact—

one had written almost conflict—with the public. It is in connexion with *The Yellow Book*, probably, that he will be most widely remembered, and it is the *Yellow Book* period of his existence that is most prominently represented in this collection of his works. The method adopted by him during this period, though the outcome of previous efforts, is distinctive, and with kaleidoscopic versatility he branched into an altogether different one after its close. If one may employ an illustration from the science of embryology—one not inappropriate to Beardsley's peculiar cast of thought —his art was like the growth of an unborn organism, reflecting at different stages all the traits of a distant ancestry. We see it in a crude archaic form, striving with imperfect means to express the ideas which are already there. We trace its Pre-Raphaelite devotional stage ; its ripe classical period ; and at the last a sort of Romantic epoch, very sensitive and delicate, very decorative, and wonderfully elaborate. Taking the " Rape of the Lock " drawings as the cream of this last period, there is much to be said for the judgment of those who consider this work of Beardsley's the best that he ever did. But I doubt very much if it was the most characteristic of Beardsley. For this I believe one must go back to the year, or year and a half, when he was startling the public in the pages of *The Yellow Book*, and frightening even his publisher with the boldness of the drawings for " Salome." The public nerves, however, become gradually insensitive to one particular kind of shock, and thus it is that it has now become possible, I am glad to say, to publish many things which at the time were considered inadmissible. To this category belong two of the illustrations to " Salome," which were withdrawn for reasons difficult to penetrate, but doubtless valid at the time. Some other alterations which were made in Beardsley's work it is impossible to restore even if one would, and the wisdom of doing so is not always unquestionable. The *Yellow Book* period of Beardsley's activity not only includes the fifteen illustrations for " Salome," a com-

7

mission obtained for him by the early drawing published in *The Studio*, but also the long series of cover designs for the " Keynotes " novels, with their initial keys, and a sprinkling of frontispiece drawings for different books, of which that from " Earl Lavender " is one of the most striking and important. It is pleasant to find among the archives of *The Yellow Book* several unpublished treasures, such as the frontispiece done for a projected " Venus and Tannhäuser," the design of which has been used in the cover of this book, and another very decorative design which has been reproduced for a title-page.* These alone are almost a justification, if one were needed, for publishing the collected works of Beardsley at this period.

I have ventured to sketch out Beardsley's career roughly in stages, from an embryological standpoint. The reference is opportune for mentioning an idea which I know is held by more than one sympathetic admirer, that if Beardsley had lived he would have developed into something totally different from what he was, possibly into a colourist of great subtlety and originality. He was in the common habit of colouring his black-and-white drawings after they had been reproduced, and one or two things done in colour—such as the sketch of Mdlle de Maupin in the possession of Mr. Leonard Smithers, and the original drawing of " Messalina "—reveal a charming feeling for colour, softened and weakened down as one might expect from such a frail constitution. Beardsley could hardly have been a vigorous colourist. But, be this as it may—and it is sheer guesswork— there is for those who can see it a remarkable suggestion of colour in some of his best black-and-whites. This is a quality possessed by only a few men, and Beardsley himself was quite conscious of it. It has no particular relevance, however, to the notion I have just mentioned, which regards the Beardsley we all know as a beginner cut short just as he was about to blossom forth, a student just about to attain his masterhood, an embryonic being stilled before his proper time of birth.

* The "Venus and Tannhäuser" design, not reproduced separately in the Dover edition, consists of the ornamental columns and entablature used as one element in Plate 44 of the *Later Work* volume. The

Aubrey Vincent Beardsley

Beardsley's personality has been admirably handled by Mr. Arthur Symons in the *Fortnightly*, and by " Max " in a recent number of *The Idler*. I cannot pretend to add anything to their knowledge, which was more intimate than my own. Beardsley, as I knew him, was a model of daintiness in dress, affected apparently for the purpose of concealing his artistic profession. It was part of his pose to baffle the world. He did it in his exterior manner as effectually as in his work. Those who imagine from the character of some of his subjects that Beardsley went about preaching or discussing vice are quite beyond the mark. Externally, at any rate, he was a pattern of moral decorum, warped only into such eccentricities. as working by candle-light, with the shutters closed, at drawings of dubious propriety, when outside the sun was shining brightly on a healthy, virtuous world. He preferred candle-light, and he selected the subjects which amused his fancy, or tickled his instinct for *gaminerie*, and that's an end on't. Max Beerbohm conceives that his mind was still that of the schoolboy playing at being vicious, and rather attracted by naughtiness. This may be so, but at the same time it must be conceded that few artists have had such an extraordinarily deep penetration into the hidden abysses of sin, and such a lurid power of suggesting them. It would have been better for his reputation if he had not ; but he chose to belong to a modern school of cynicism, and to depict life mostly in its more animal or brutish aspects ; and that again is his own affair. It is the artist as he is that one must reckon with, not the artist we could have made him ; and to condemn a man for adopting different ideas and a different standard from one's own is as absurd as condemning him for wearing different clothes—which, as a matter of fact, nine out of ten of us are quite ready to do.

It was really, as I think Mr. Symons has pointed out, a lack of reverence that was at the bottom of Beardsley's taste in subjects. He could draw beautiful subjects as beautifully as any one. I know few things more

decorative frame used on the title-page of the original edition of both the *Early Work* and *Later Work* now appears in its regular sequence as Plate 2 of both volumes.

9

flawless than his design of a " Venus standing between Terminal Gods,"
or " The Coiffing," which appeared in *The Savoy*. Certainly there is no
suggestion of vice in these, or in scores of his other drawings. His " Venus
and Tannhäuser " was to have contained no ugly suggestions. Even when
in his love of shocking the public he deliberately chooses a vicious type,
his true passion for beauty expresses itself in the manner of his execution.
This manner of execution it has become fashionable to refer to as " Beards-
ley's line." I do not know who was first responsible for pointing out the
beauties of the Beardsley " line," but, whoever it was, I could have wished
that he had accompanied it with some explanation of what is meant by the
phrase. Beardsley had many " lines," all exquisite in execution, and of
varying degrees of fineness, the most remarkable being somewhat akin
to an angler's line, as may be seen to perfection in the drawing for " Salome,"
entitled " The Peacock Skirt." But a " line," as the phrase is now commonly
understood, such a " line " as that of Forain, eloquent in its bold simplicity
of manifold unexpressed details, Beardsley does not seem, at all events
to me, to possess. There may be hints of it. Mr. Gleeson White, in
The Studio, instanced the wan, pinched face of the dead Pierrot in one of
the *Savoy* illustrations, which none would dispute, and many of the outline
drawings in this volume contain a sense of modelling, wonderfully implied ;
but this compression of method is certainly not the main, nor even an
important feature of Beardsley's work. Paradoxically I can imagine some
one retorting that his forte is rather his " mass." The point is not worth
pursuing, for it belongs to that slippery region of problems which depend
upon the meaning of terms. Some people may see in Beardsley's work
the perfection of what they call " line," and for them Beardsley's " line "
must possess a definite technical meaning.

One thing at all events is clear, and that is, that Beardsley was essen-
tially a decorative artist. All his arrangement and handling of subjects,

his treatment of the human figure, his use of landscape, was subordinate to the ultimate decorative effect. No trace of " naturalism " ever creeps in to mar the set convention of his work. In his treatment of nature he is as formal as any missal scribe of the fifteenth century, as mannered as the old Egyptian or the modern Japanese. Conformably, he was quite indifferent to what may be called the dramatic or historical unities. He would cheerfully clothe Isolde in an *outré* Parisian " confection," or Messalina in an ostrich-feather hat—nay, has done both. The decorative effect was all he cared for, and, if the public failed to appreciate the humour of his anachronisms, so much the worse for them. The source of his decorative inspirations has often been canvassed, though a good deal of it is fairly obvious. In his earliest drawings worthy of mention, the " Morte d'Arthur," the " Procession of Jeanne d'Arc," " Hamlet following the Ghost," " Hail Mary," " Perseus and the Monstre," and others which any one can find for himself, he was under considerable obligations to the most generous of his early patrons, Sir Edward Burne-Jones. Then the Japanese caught his wayward fancy and gave us the " Femme Incomprise " (*To-day* and *Idler*), " Madame Cigale," and indirectly much of the *Yellow Book* work, in which, however, he developed a new conceit, which fully deserves to rank as original. His passion for Pierrot, the most pathetic as well as the most humorous conception that has come down to us, stands evident in his latest as well as in some of his earliest work, and it is interesting to learn, on the authority of an old school friend, that he was immensely affected when a mere boy by the influence of " L'Enfant Prodigue." I have recently heard another theory advanced which may be worth mentioning, to account for the very persistent use of rococo ornamentation in his drawings of furniture, candelabra, wall-hangings, &c. This peculiarity is so striking as really to suggest some concrete source of inspiration, and, odd as it may sound, this source of inspiration was not improbably the florid gaudiness of the

interior of the Brighton Pavilion, of which, in his schooldays, Beardsley was something of an *habitué*. The Casino, at Dieppe, doubtless contributed also its quota of ideas. One might go on indefinitely proposing models for individual pieces of work, if one cared to and if the subject were worth pursuing. But, broadly, it may be taken as a fact that Beardsley, if himself inimitable, was nevertheless highly imitative ; that he could purloin a method, and so absorb it as to render it wholly his own ; that when he apparently changed his style with lightning rapidity, as in the transition from his *Yellow Book* to his " Rape of the Lock " manner, he did not really evolve some perfectly novel convention, but merely worked up a fresh " rave "—in this particular instance the style of the eighteenth-century French engravers.

That his transitions took a certain form and order I have ventured to indicate above, but the idea of a chronological or embryological sequence must not·be pushed too far—indeed, it is necessary to qualify almost any statement that may be made about so complex and variable a being. Beardsley himself signified his consciousness of the breaks in his method of working by adopting successive forms of signature. In his earliest (juvenile) drawings he is always " A. V. B.," or " Aubrey V. Beardsley." Later he dropped the " V," and used only the first and third initials of his name. In the illustration to " Pastor Sang " he appears to acknowledge a debt to Dürer by ranging his initials in the form of the well-known Dürer monogram. He might more appropriately have borrowed the " L. H." of Mr. Housman. A long series of drawings, beginning with the " Questing Beast " plate in the " Morte d'Arthur," and continuing down through *The Pall Mall Budget*, " Salome," and what may be generically classified as the *Yellow Book* period, are signed with what has been called his Japanese mark, three strokes ranged in a particular manner, with or without dots or other ornamental accessories. The apotheosis of this device will be found on the reverse side of the cover of this volume,[*] repro-

* Not on the cover in the present Dover edition, but reproduced as Plate 156 of this volume.

duced from the " Salome." In his later work Beardsley mostly wrote his two names in full, in capitals, along the bottom border line of the drawing. All sorts of variations occur at different times, which may mean something, or nothing. In an ordinary person they would mean nothing, but Beardsley was not an ordinary person, and his subtleties were infinite, inviting and yet often defying analysis.

Separate mention should be made in this connexion of the two drawings which appeared in *The Yellow Book* under fictitious signatures. These were the Mantegna head, which was signed " Philip Broughton," and a pastel study of a Frenchwoman, signed " Albert Foschter." Both are to be found reproduced in this volume in their proper places chronologically. Beardsley's purpose in indulging in this freak was an idea of " scoring off " the critics who were accustomed to attack his work as soon as it appeared. He did not care much about unfavourable criticism ; he rather enjoyed it than otherwise ; but he could not resist the temptation, during one of his transient avatars, of setting a trap by varying his style. Mr. Max Beerbohm declares that the plot was entirely successful, and that one reviewer solemnly advised Beardsley to " study and profit by the sound and scholarly draughtsmanship of which Mr. Philip Broughton furnished another example in his familiar manner." I must confess that, although I was in the secret of the *alias*, I never saw this profound piece of criticism upon it ; but, if it really appeared anywhere, I can well believe that Beardsley was " greatly amused and delighted " by it.

All who knew Beardsley will bear witness to many pleasant personal traits : his extraordinary love of music, his rippling wit, his wide range of reading, his capacity for hard work without even appearing to be busy. He worked mostly at night. His many sidedness has been briefly summed up in the first paragraph of Mr. Symons's memoir, which I venture to quote.

" He had the fatal speed of those who are to die young ; that dis-

quieting completeness and extent of knowledge, that absorption of a lifetime
in an hour, which we find in those who hasten to have done their work
before noon, knowing that they will not see the evening. He had played
the piano in drawing-rooms as an infant prodigy, before, I suppose, he had
ever drawn a line. Famous at twenty as a draughtsman, he found time,
in those incredibly busy years which remained to him, deliberately to train
himself as a writer of prose, which was in its way as original as his draughts-
manship, and into a writer of verse which had at least ingenious and original
moments. He seemed to have read everything, and had his preferences
as adroitly in order, as wittily in evidence, as almost any man of letters ;
indeed, he seemed to know more, and was a sounder critic, of books than of
pictures ; with perhaps a deeper feeling for music than for either. His
conversation had a peculiar kind of brilliance, different in order, but scarce
inferior in quality to that of any other contemporary master of that art ;
a salt, whimsical dogmatism, equally full of convinced egoism and of im-
perturbable keen-sightedness. Generally choosing to be paradoxical, and
vehement on behalf of any enthusiasm of the mind, he was the dupe of none
of his own statements, or indeed of his own enthusiasms, and, really, very
coldly impartial. He thought, and was right in thinking, very highly of
himself ; he admired himself enormously ; but his intellect would never
allow itself to be deceived even about his own accomplishments."

What drove him out of his many different accomplishments to seek
art as his chief field is not quite clear. It may have been the advice of
Burne-Jones and of Puvis de Chavannes ; it may have been the scent of
an immediate and satisfying *réclame* ; it may have been the necessity for
making money. Probably all of these causes conspired. Why, turned
artist, he should have developed such a grim satirical humour, is equally
uncertain, unless it were his affection for Juvenal grafted on the bitterness
of one who knows that he is in the grip of death, that few and evil must

be the days of his life. Over all this, like Pierrot, he wore a brave mask, and faced his tragedy with a show of laughter. How he suffered, how he worked, he never permitted to be seen. If the irony took a grim form sometimes in the jests that he flung to the public, in the scorn he allowed himself to feel for a world that had not got to die, can we wonder ? Pierrot's humour has mostly a subacidity, or we should fail to relish it.

Those who live healthy normal lives, unracked by hæmorrhage, untroubled by genius, may try to picture the life of one harassed by both at once. They may hate the man's work if they must, and if their souls are built that way, but they might try and find some spark of sympathy and admiration for the man. One can scarcely realize what it means to have only six real years of life, and to feel that they are precarious. To have done as much in them as Beardsley did, of actual solid work, is no mean achievement, apart from the fact that so much is work of almost microscopic delicacy. A great deal of it too, one is apt to forget, is work of unsullied beauty—free from the questionable traits which have hurt his reputation with the public. Finally it must not be lost sight of that the *rôle* he played was that of a satirist ; that in depicting vice he held it up for scourging ; that in exaggerating its fanciful side he but accentuated its squalid and horrible reality.

Poor Beardsley ! His death has removed a quaint and amiable personality from amongst us ; a butterfly who played at being serious, and yet a busy worker who played at being a butterfly. Outwardly he lived in the sunshine, airing bright wings. Inwardly no one can tell how he suffered or strove. It is well to avoid self-righteousness in judging him. As the wise pastrycook says in *Cyrano*,—

" Fourmi, n'insulte pas ces divines cigales."

H. C. MARILLIER

KELMSCOTT HOUSE
HAMMERSMITH
January 1899

15

PLATES

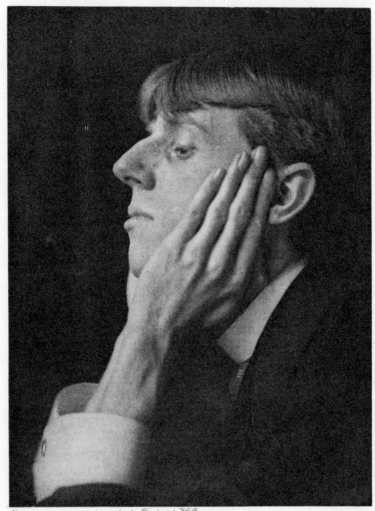

From a private portrait study by Frederick H. Evans.

Plate 1

Plate 2

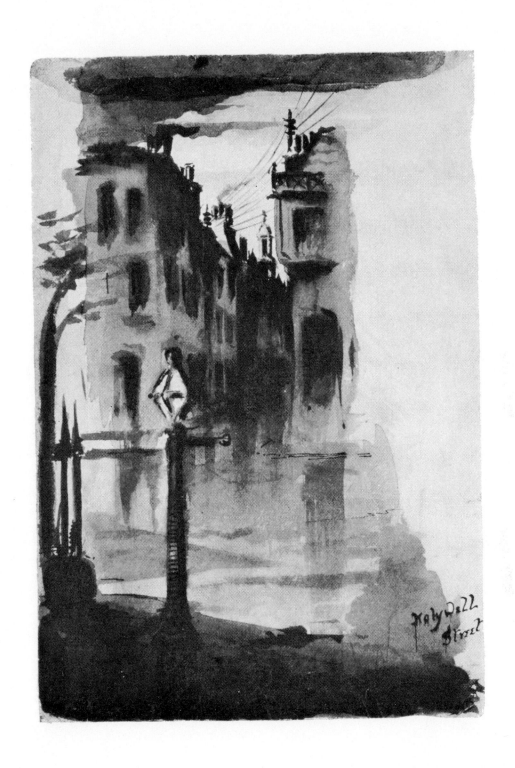

Plate 3

EARLY SKETCH OF HOLYWELL
STREET. BY PERMISSION OF
MR. C. B. COCHRAN

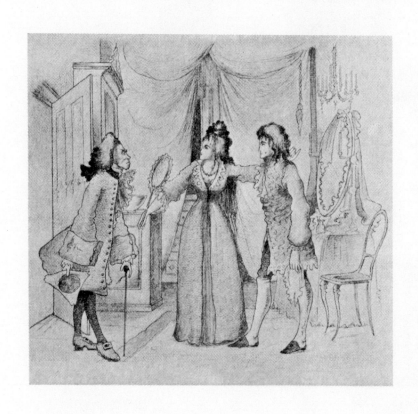

Plate 4

A SCENE FROM "MANON LESCAUT."
REPRODUCED BY PERMISSION OF
MR. R. B. ROSS

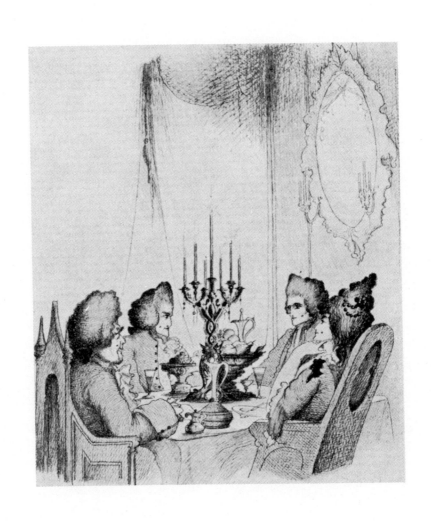

Plate 6

A SCENE FROM "MANON LESCAUT."
REPRODUCED BY PERMISSION OF
MR. R. B. ROSS ⊠ ⊠ ⊠ ⊠

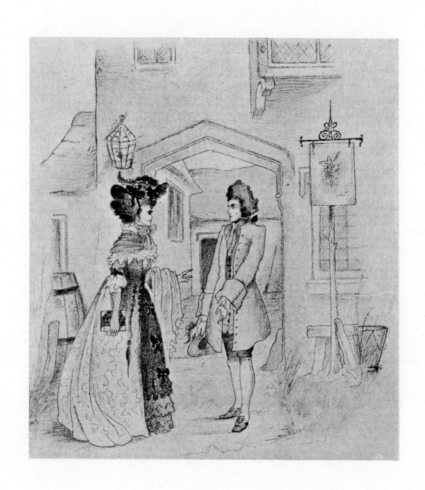

A SCENE FROM "MANON LESCAUT."
REPRODUCED BY PERMISSION OF
MR. R. B. ROSS ⊠ ⊠ ⊠ ⊠

Plate 5

HERMAPHRODITUS

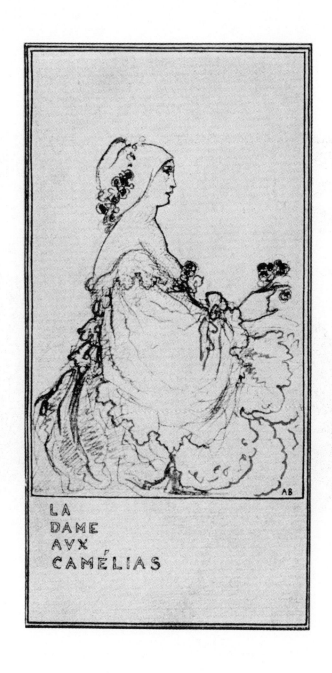

LA DAME
AVX
CAMÉLIAS

LA DAME AUX CAMÉLIAS.
REPRODUCED FROM A WATER-COLOUR ON
THE FLY-LEAF OF A COPY OF "LA DAME
AUX CAMÉLIAS" GIVEN TO AUBREY
BEARDSLEY BY ALEXANDRE DUMAS, FILS

Plate 7

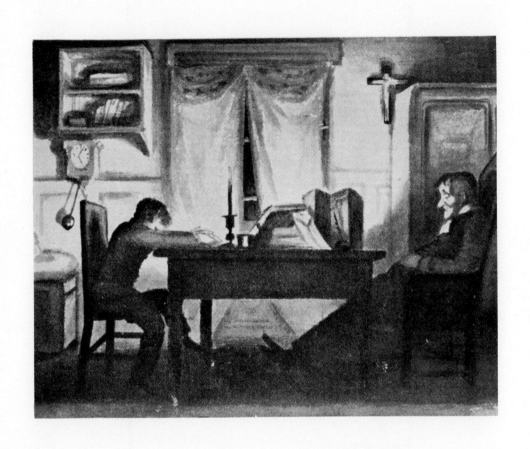

Plate 8

A SCENE FROM "MADAME BOVARY."
REPRODUCED BY PERMISSION OF
MR. R. B. ROSS

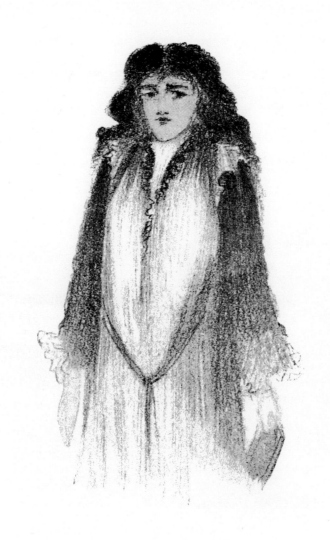

Plate 9

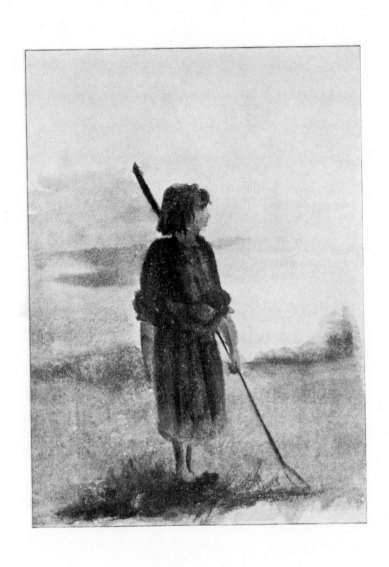

Plate 10

JOAN OF ARC. BY PERMISSION
OF MR. R. B. ROSS ✠ ✠ ✠

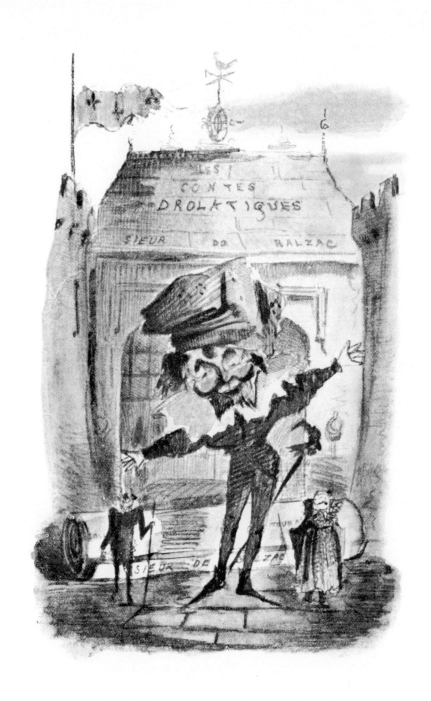

Plate 11

FRONTISPIECE TO BALZAC'S "CONTES
DRÔLATIQUES." BY PERMISSION OF
MR. R. B. ROSS ⊠ ⊠ ⊠ ⊠

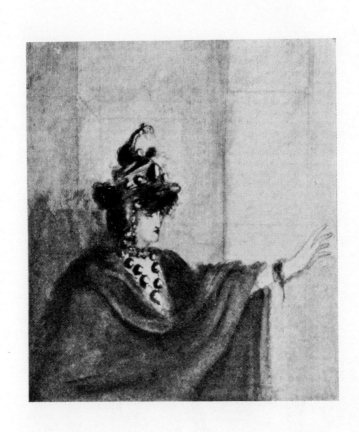

Plate 12

PHÈDRE. BY PERMISSION
OF MR. R. B. ROSS ⊠ ⊠

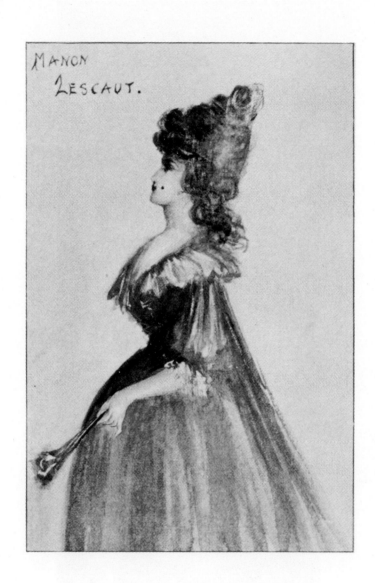

Plate 13

MANON LESCAUT. BY PER-
MISSION OF MR. R. B. ROSS

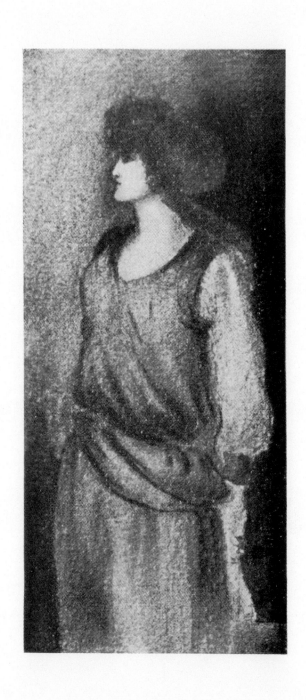

Plate 14

BEATRICE CENCI. BY PER-
MISSION OF MR. R. B. ROSS

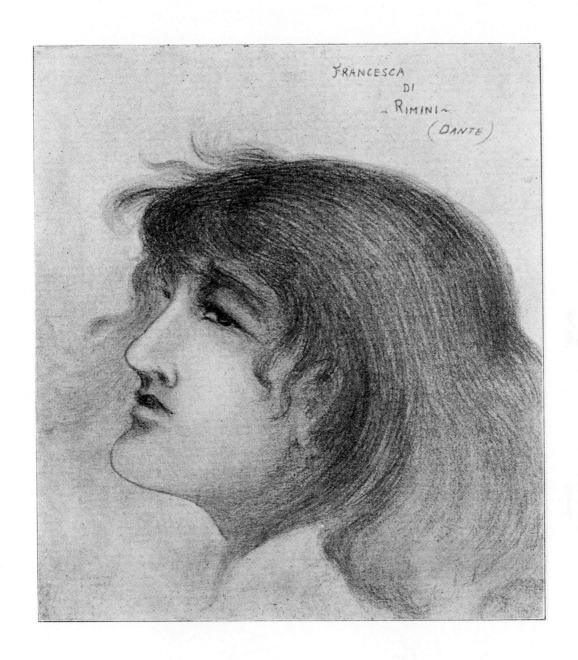

FRANCESCA DI RIMINI (DANTE). BY
PERMISSION OF MR. MORE ADEY

Plate 15

DANTE IN EXILE. BY PERMISSION
OF MR. HAMPDEN GURNEY

Plate 16

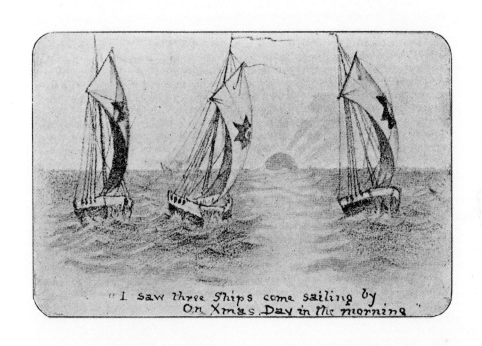

"I saw three Ships come sailing by.
On Xmas Day in the morning"

Plate 17

"I SAW THREE SHIPS COME SAILING BY." BY PERMISSION OF MR. HAMPDEN GURNEY ✠ ✠ ✠ ✠

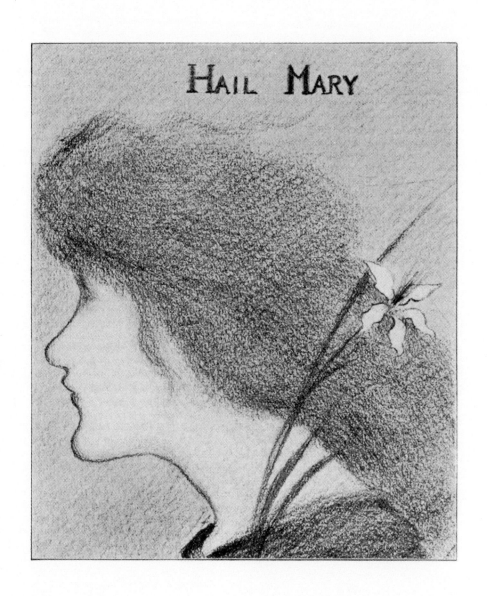

Plate 18

HAIL MARY. PENCIL SKETCH. BY
PERMISSION OF MR. F. H. EVANS ⊗

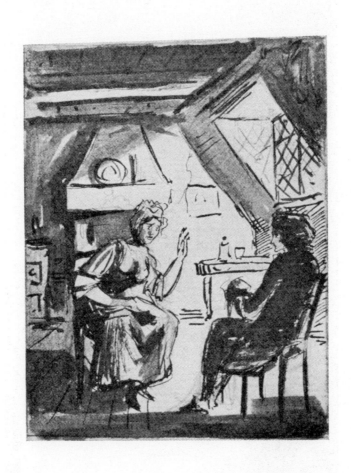

Plate 19

TWO FIGURES IN AN ATTIC. INK
AND WASH SKETCH. BY PERMIS-
SION OF MR. F. H. EVANS

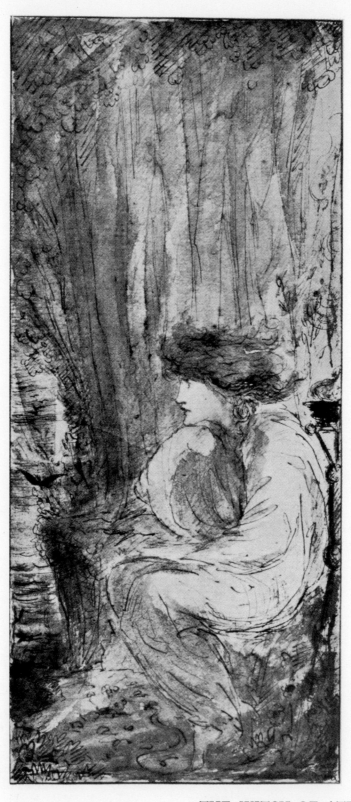

Plate 20

THE WITCH OF ATLAS. BY PER-
MISSION OF MR. R. B. ROSS

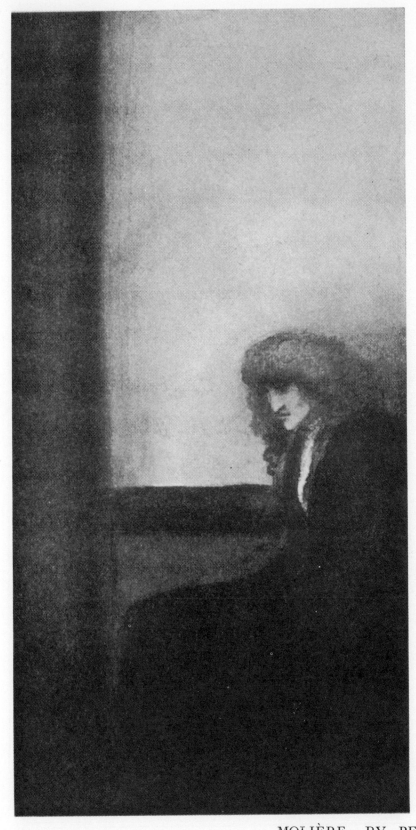

Plate 21

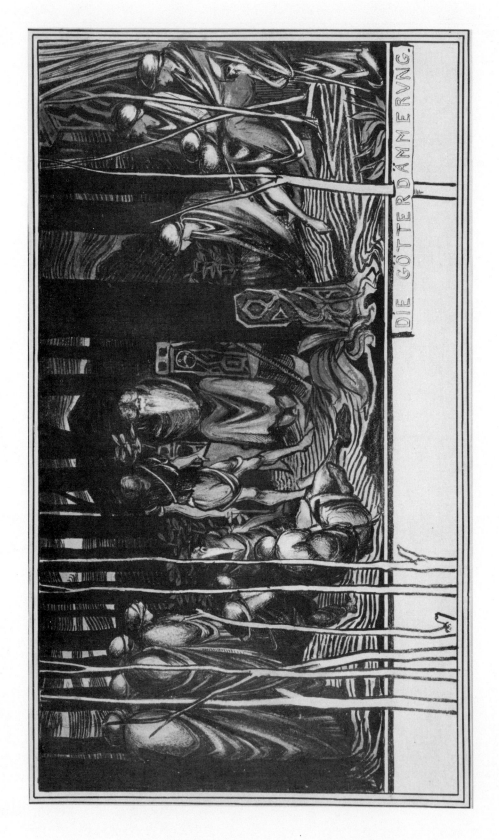

DIE GÖTTERDÄMMERUNG. BY
PERMISSION OF MR. R. B. ROSS

Plate 22

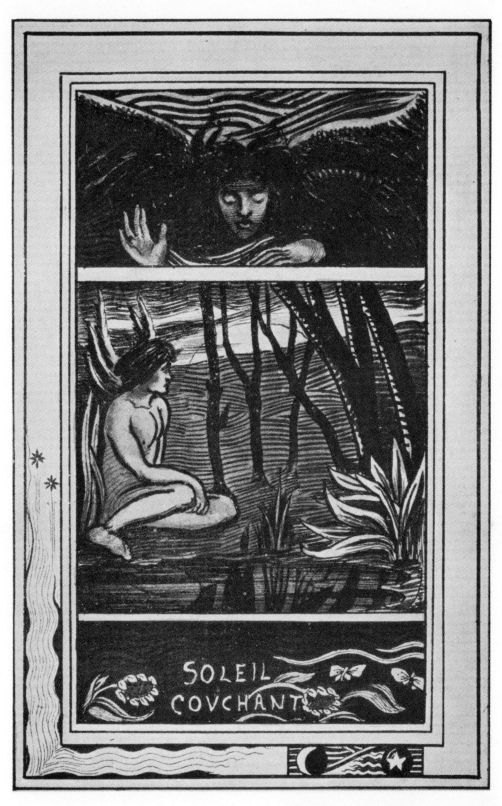

SOLEIL COUCHANT

Plate 23

SOLEIL COUCHANT. BY PERMIS-
SION OF MR. HAMPDEN GURNEY

Plate 24

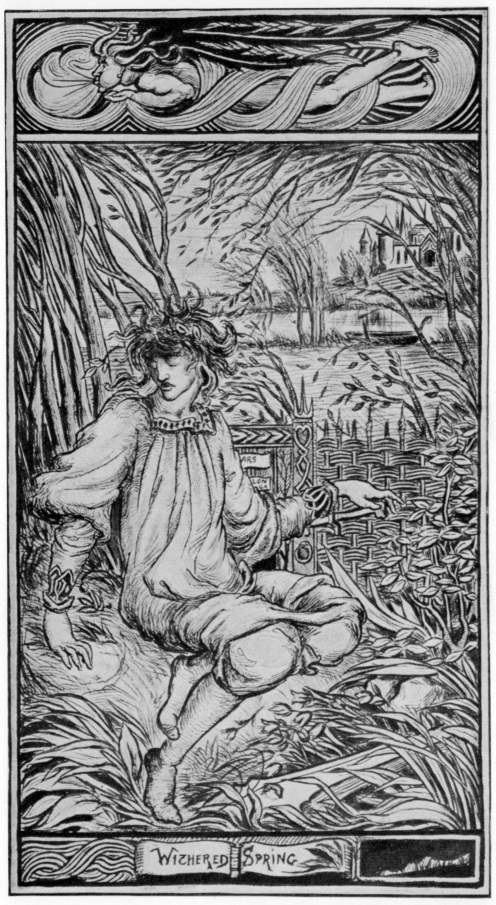

WITHERED SPRING

WITHERED SPRING. BY PERMISSION
OF DR. ROWLAND THURNAM

Plate 25

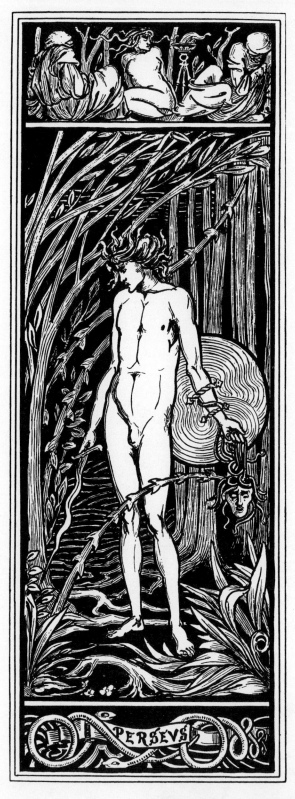

Plate 26

"PERSEUS." (DESIGN IN INK FOR
A PANEL; UNFINISHED.) BY PER-
MISSION OF MR. F. H. EVANS

A PENCIL SKETCH OF FIGURES, FROM THE BACK OF "PERSEUS." BY PERMISSION OF MR. F. H. EVANS

Plate 27

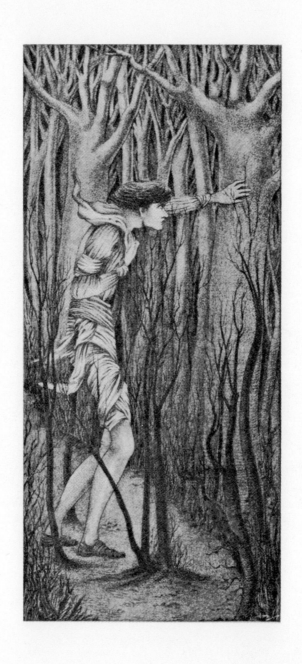

Plate 28

HAMLET. FROM "THE BEE"
MAGAZINE, DECEMBER 1892

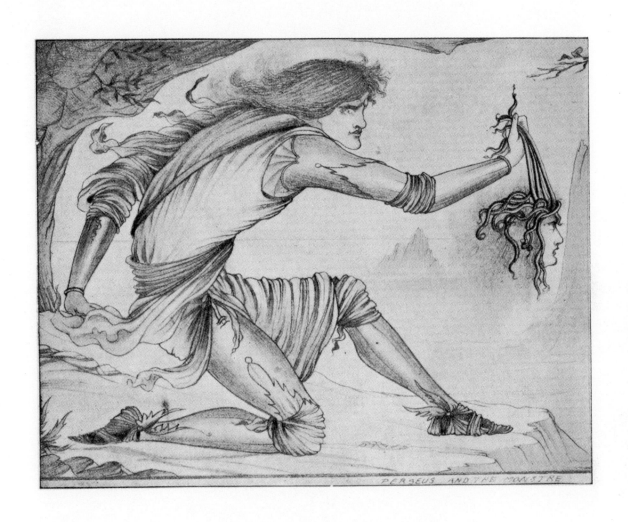

"PERSEUS AND THE MONSTRE." FROM
A PENCIL DRAWING IN THE POSSES-
SION OF MR. AYMER VALLANCE. BY
PERMISSION OF MESSRS. CASSELL AND
CO., LIMITED ✠ ✠ ✠ ✠ ✠

Plate 29

THE PROCESSION OF JEANNE
D'ARC. BY PERMISSION OF
MR. F. H. EVANS ✠ ✠ ✠

Plate 30

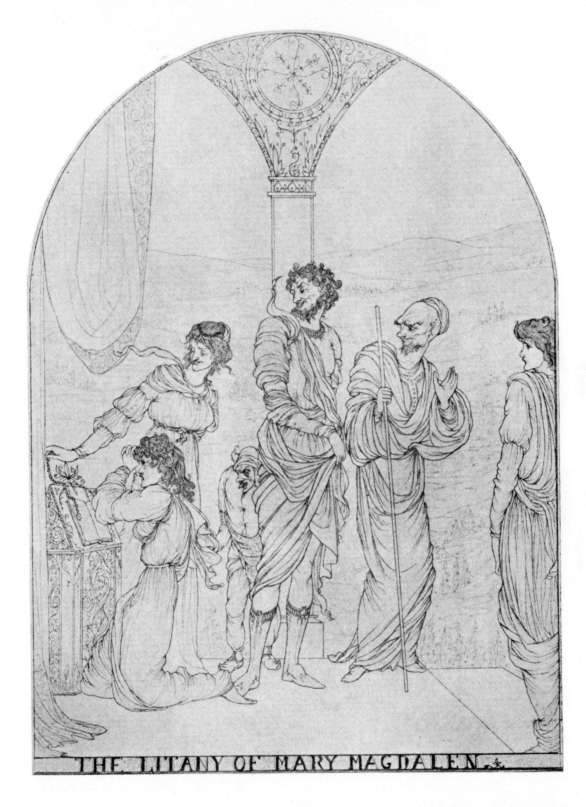

THE LITANY OF MARY MAGDALEN.

THE LITANY OF MARY MAGDALEN.
BY PERMISSION OF MR. MORE ADEY

Plate 31

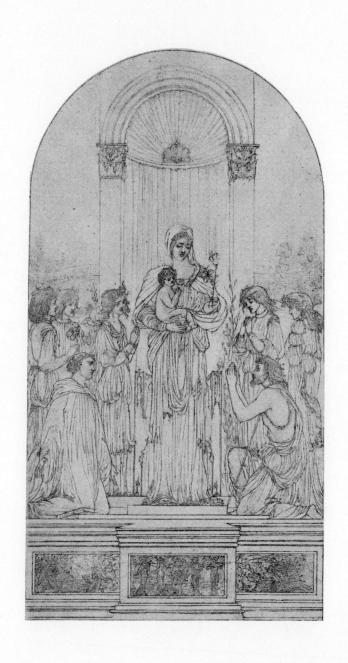

Plate 32

THE VIRGIN AND THE LILY. BY
PERMISSION OF MR. HAMPDEN
GURNEY

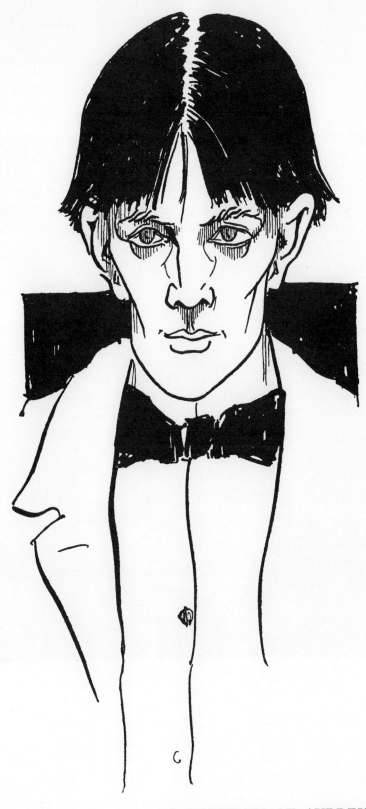

A PORTRAIT OF AUBREY BEARDSLEY
BY HIMSELF. REPRODUCED BY PER-
MISSION OF MR. R. B. ROSS

Plate 33

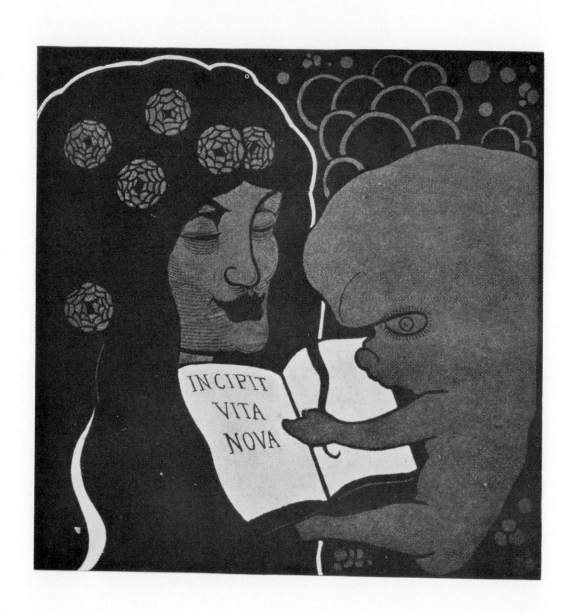

Plate 34

INCIPIT VITA NOVA. BY PERMIS-
SION OF MR. MORE ADEY ⊠ ⊠

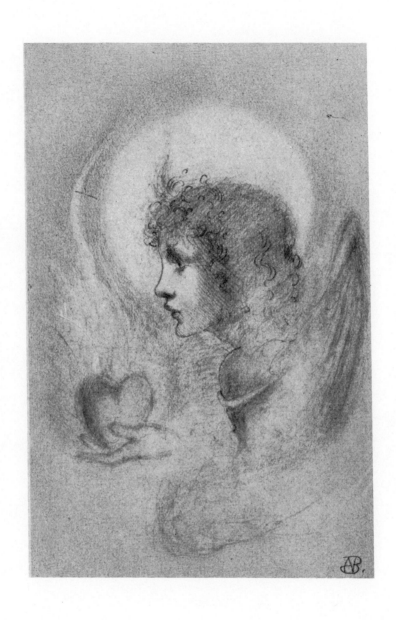

Plate 35

A HEAD. BY PERMISSION
OF MR. HAMPDEN GURNEY

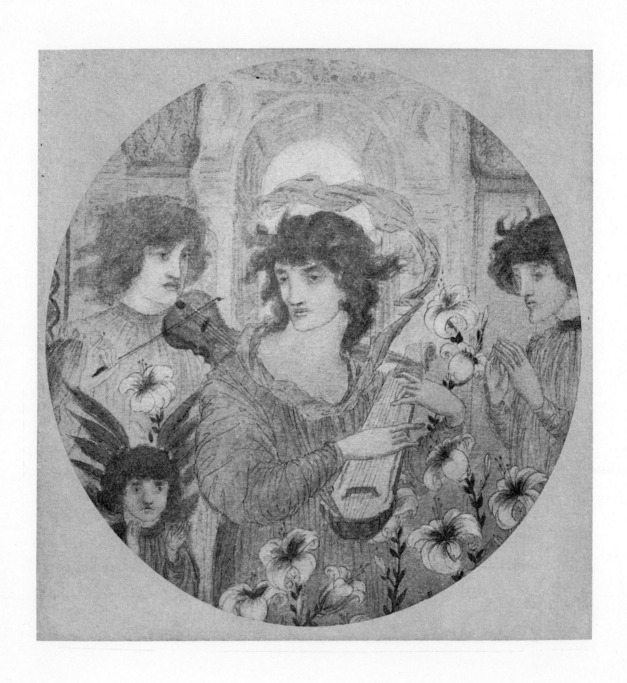

Plate 36

ADORAMUS TE. BY PERMISSION
OF MR. HAMPDEN GURNEY

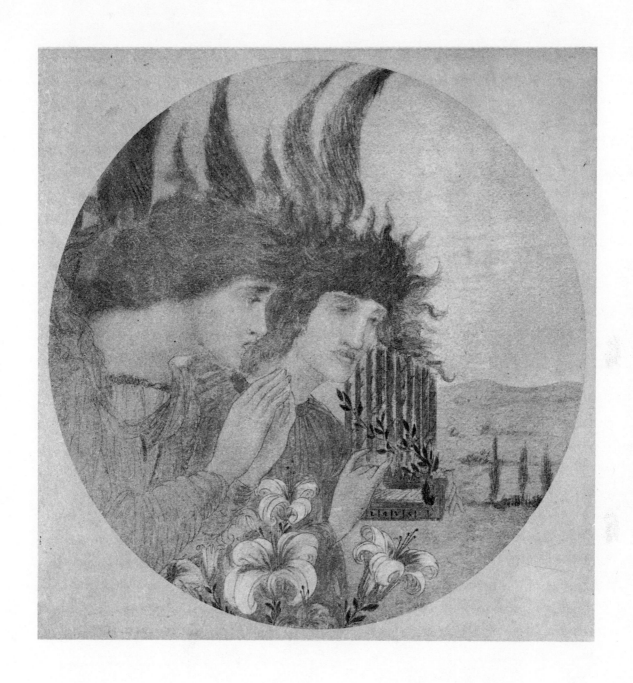

Plate 37

A CHRISTMAS CAROL. BY PERMIS-
SION OF MR. HAMPDEN GURNEY ⊠

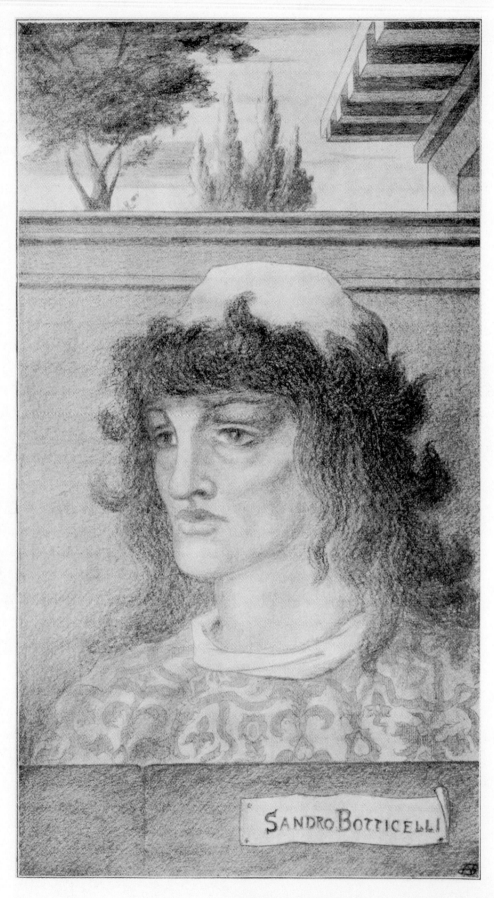

SANDRO BOTTICELLI. FROM A DRAW-
ING IN THE POSSESSION OF MR. AYMER
VALLANCE. BY PERMISSION OF MESSRS.
CASSELL AND CO., LIMITED

Plate 38

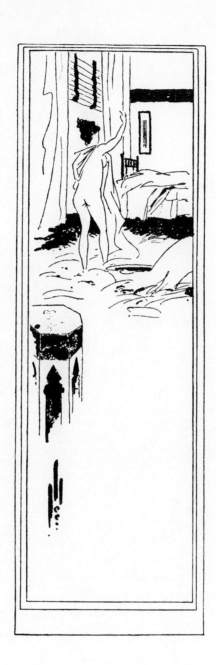

Plate 39

A BOOK-MARK. REPRODUCED
BY PERMISSION OF MR. R. B. ROSS

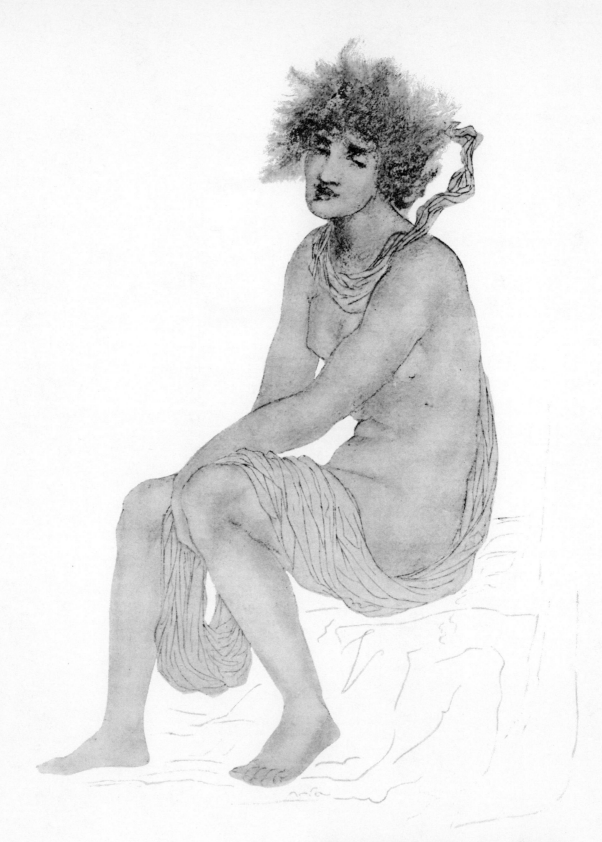

Plate 40

HERMAPHRODITUS. BY PERMIS-
SION OF MR. JULIAN SAMPSON
*This plate also appears in color between
Plates 4 and 5.*

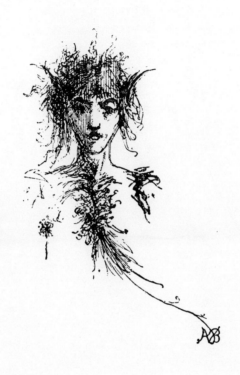

Plate 41

VIGNETTE. FOR MALLARMÉ'S
"L'APRÈS-MIDI D'UN FAUNE"

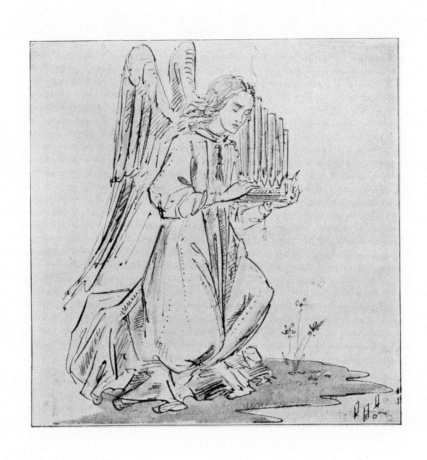

ANGEL WITH ORGAN. FROM A
SKETCH IN THE POSSESSION OF
MR. AYMER VALLANCE. BY PER-
MISSION OF MESSRS. CASSELL
AND CO., LIMITED ✠ ✠ ✠

Plate 42

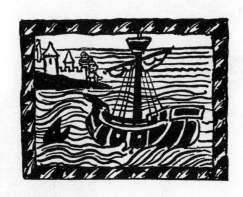

VIGNETTE. FROM A DRAWING
IN THE POSSESSION OF MR.
AYMER VALLANCE. BY PERMIS-
SION OF MESSRS. CASSELL AND
CO., LIMITED

Plate 43

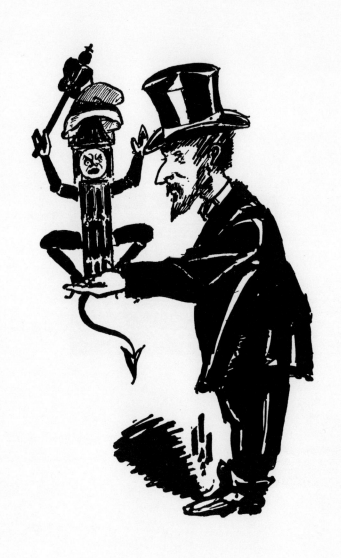

MR. HENRY ARTHUR JONES AND
HIS BAUBLE. BY PERMISSION OF
THE PROPRIETOR OF " THE PALL
MALL BUDGET "

Plate 44

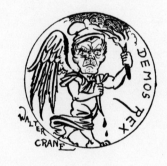

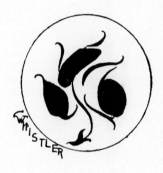

Plate 45

FOUR DESIGNS FOR "THE NEW
COINAGE." BY PERMISSION OF
THE PROPRIETOR OF "THE PALL
MALL BUDGET"

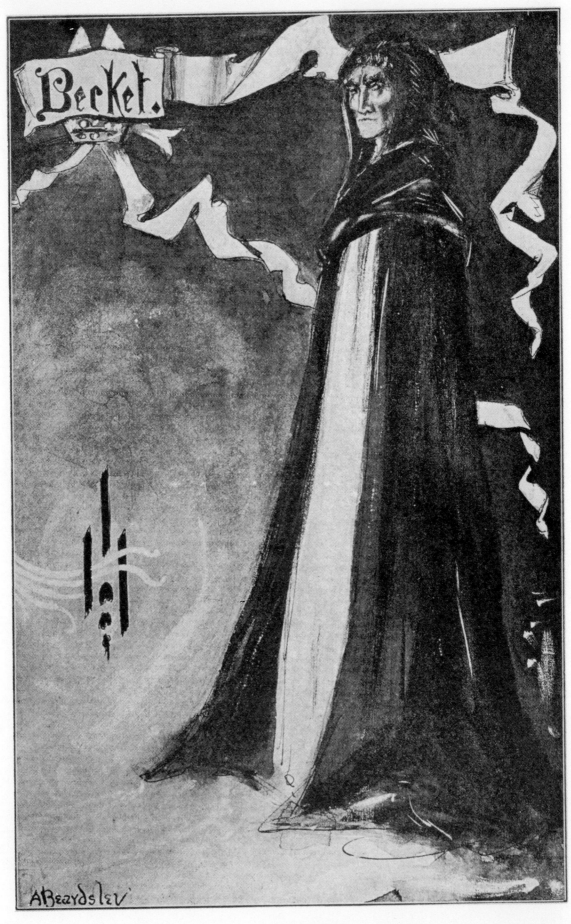

SIR HENRY IRVING AS "BECKET."
BY PERMISSION OF THE PROPRIETOR
OF "THE PALL MALL BUDGET"

Plate 46

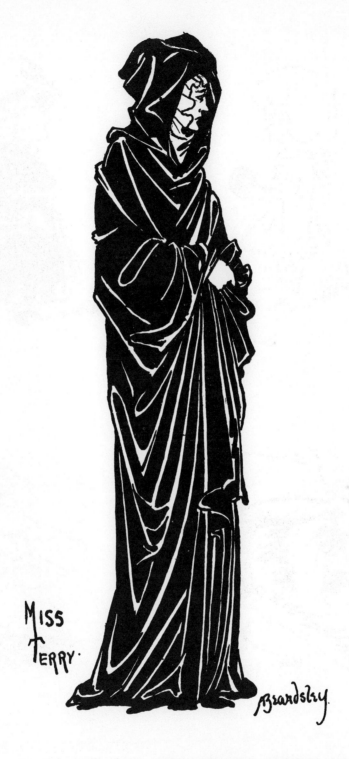

MISS ELLEN TERRY IN "BECKET.'
BY PERMISSION OF THE PROPRIETOR
OF "THE PALL MALL BUDGET"

Plate 47

MASTER LEO.

MARGERY

THE COMPOSER

THE KING MAKES A MOVE ON THE BOARD.

Plate 48

FOUR SKETCHES FROM "BECKET,"
AT THE LYCEUM. BY PERMISSION
OF THE PROPRIETOR OF "THE
PALL MALL BUDGET"

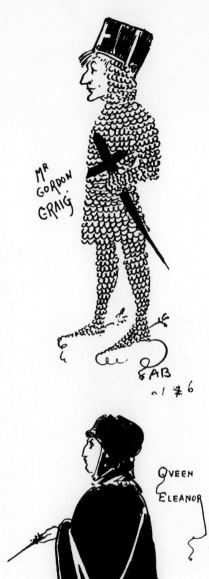

MR GORDON CRAIG.

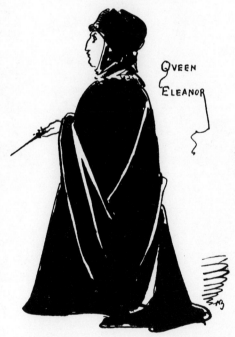

QVEEN ELEANOR

TWO SKETCHES FROM "BECKET,"
AT THE LYCEUM. BY PERMISSION
OF THE PROPRIETOR OF "THE
PALL MALL BUDGET"

Plate 49

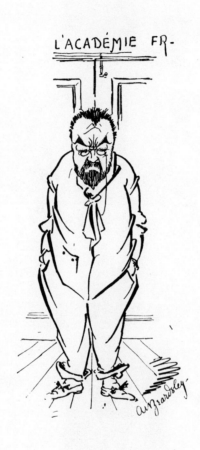

ÉMILE ZOLA AND THE ACADÉMIE FRANÇAISE. BY PERMISSION OF THE PROPRIETOR OF "THE PALL MALL BUDGET" ⊠ ⊠ ⊠

Plate 50

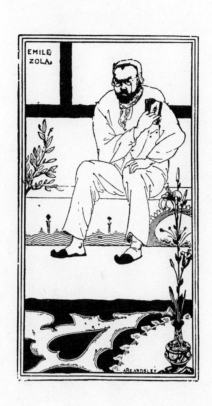

PORTRAIT OF ÉMILE ZOLA.
BY PERMISSION OF THE PRO-
PRIETOR OF "THE PALL MALL
BUDGET" ⊠ ⊠ ⊠ ⊠

Plate 51

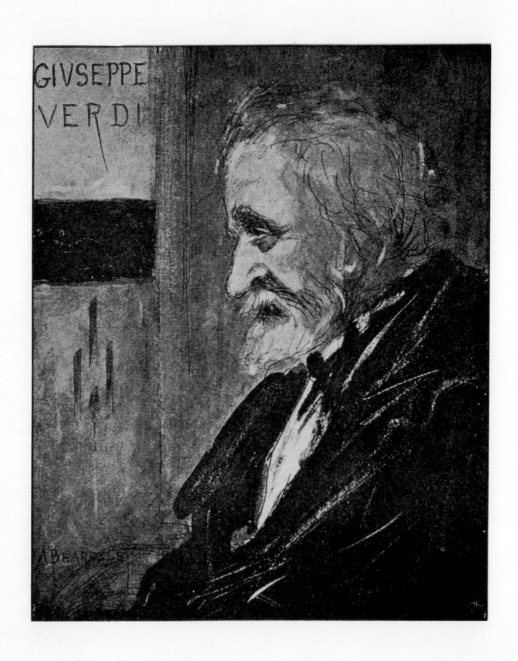

PORTRAIT OF VERDI. BY PERMIS-
SION OF THE PROPRIETOR OF "THE
PALL MALL BUDGET"

Plate 52

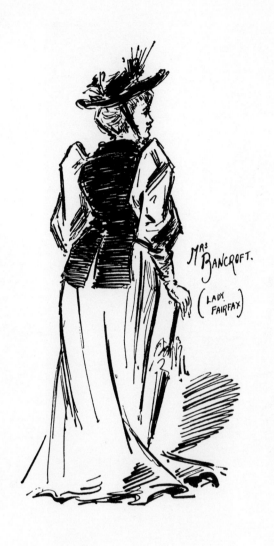

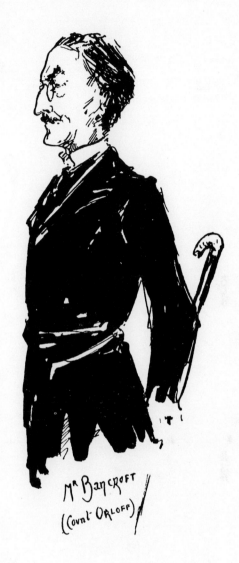

SKETCHES OF MR. AND MRS. BANCROFT
IN "DIPLOMACY," AT THE GARRICK
THEATRE. BY PERMISSION OF THE
PROPRIETOR OF "THE PALL MALL
BUDGET" ⊠ ⊠ ⊠ ⊠ ⊠

Plate 53

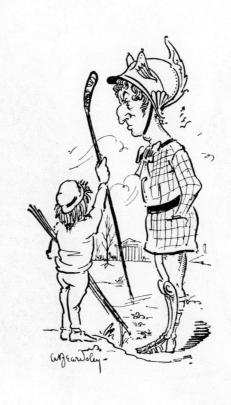

Plate 54

"ÆNEAS" ON THE LINKS. BY PER-
MISSION OF THE PROPRIETOR OF
"THE PALL MALL BUDGET" ⌖ ⌖

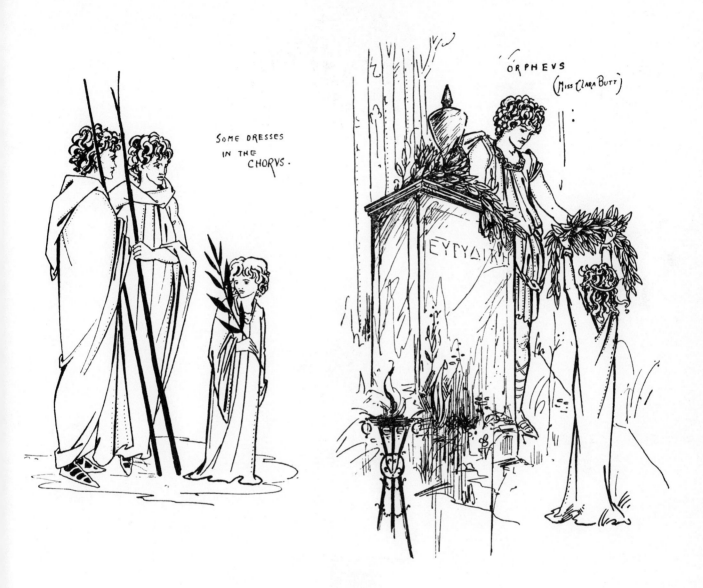

SOME DRESSES IN THE CHORVS.

ORPHEVS
(Miss Clara Butt)

EYPYΔIKH

TWO SKETCHES FROM "ORPHEUS,"
AT THE LYCEUM. BY PERMISSION
OF THE PROPRIETOR OF "THE
PALL MALL BUDGET" ⊠ ⊠ ⊠

Plate 55

ONE OF
THE SPIRITS

(ACT II)

TWO SKETCHES FROM "ORPHEUS,"
AT THE LYCEUM. BY PERMISSION
OF THE PROPRIETOR OF "THE
PALL MALL BUDGET"

Plate 56

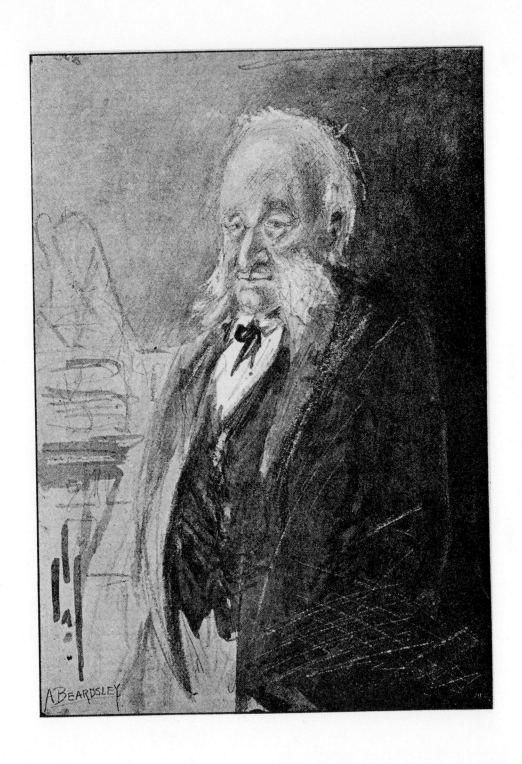

PORTRAIT OF JULES FERRY. BY
PERMISSION OF THE PROPRIETOR
OF "THE PALL MALL BUDGET"

Plate 57

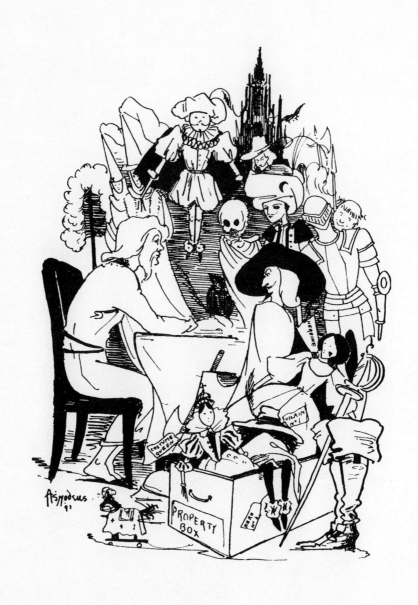

MR. HARRISON'S IDEAL NOVELIST.
BY PERMISSION OF THE PROPRIETOR
OF "THE PALL MALL BUDGET"

Plate 58

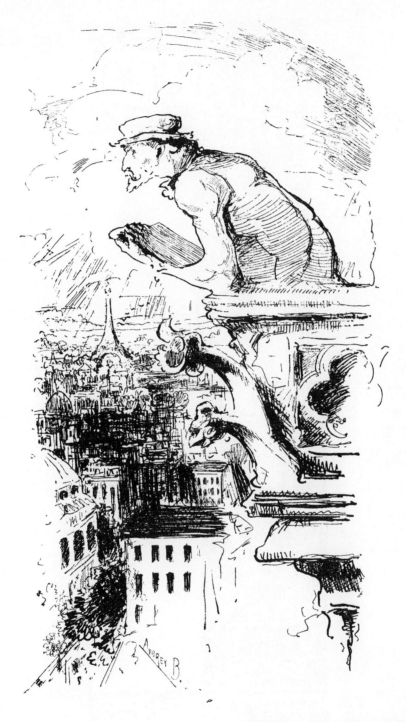

SKETCH OF MR. PENNELL AS
"THE DEVIL OF NOTRE DAME."
BY PERMISSION OF THE PRO-
PRIETOR OF "THE PALL MALL
BUDGET"

Plate 59

Plate 60

COVER DESIGN FOR "THE
STUDIO" (REDUCED). TWO
STATES. BY PERMISSION OF
MR. CHARLES HOLME

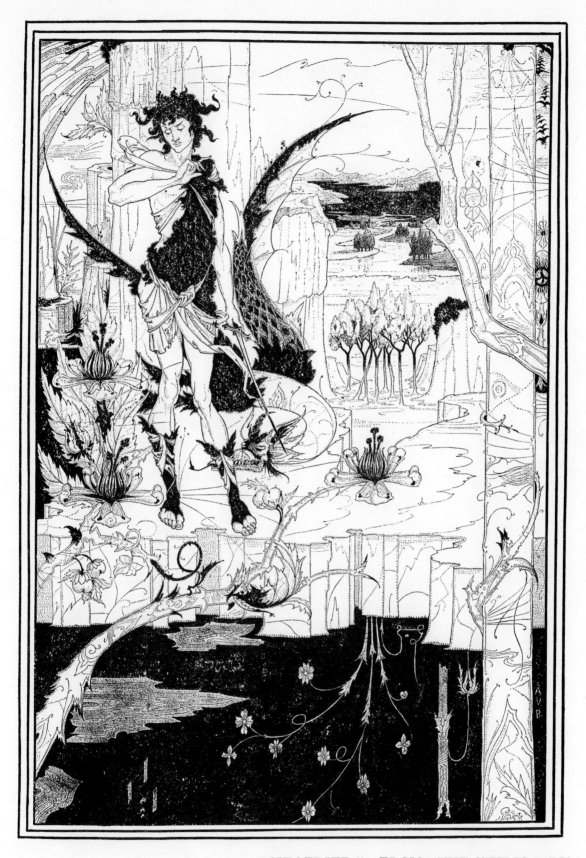

Plate 61

"SIEGFRIED." FROM "THE STUDIO." BY
PERMISSION OF MR. CHARLES HOLME

THE BIRTHDAY OF MADAME CIGALE.
FROM "THE STUDIO." BY PERMIS-
SION OF MR. CHARLES HOLME

Plate 62

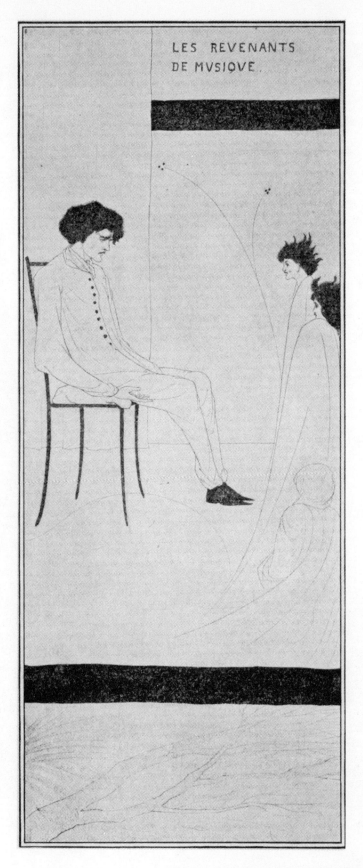

LES REVENANTS DE MUSIQUE. FROM "THE STUDIO." BY PERMISSION OF MR. CHARLES HOLME ⊠ ⊠ ⊠

Plate 63

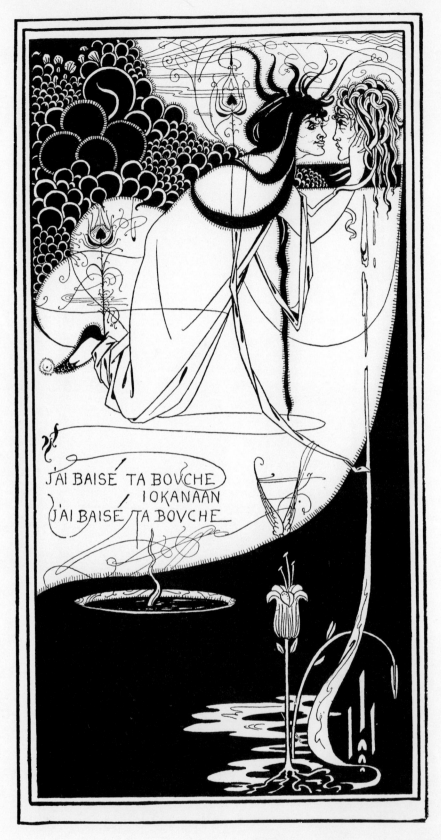

J'AI BAISÉ TA BOUCHE
IOKANAAN
J'AI BAISÉ TA BOUCHE

DESIGN FOR "SALOME." FROM
"THE STUDIO." BY PERMISSION
OF MR. CHARLES HOLME ⊠ ⊠

Plate 64

Plate 65

BORDER DESIGN. FROM
"LE MORTE D'ARTHUR"

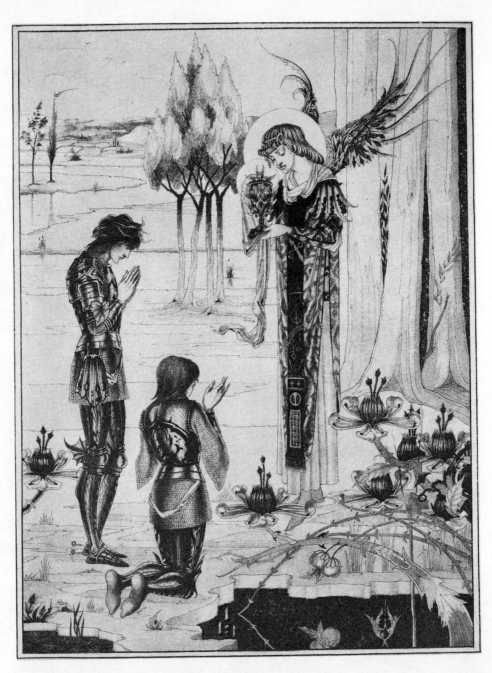

The achieuing of the Sangreal .

THE ACHIEVING OF THE SANGREAL.
FROM "LE MORTE D'ARTHUR" ⊠
THIS, AND THE EIGHTEEN DESIGNS WHICH FOLLOW,
ARE REPRODUCED BY PERMISSION OF MESSRS.
J. M. DENT AND CO. ⊠ ⊠ ⊠ ⊠

Plate 66

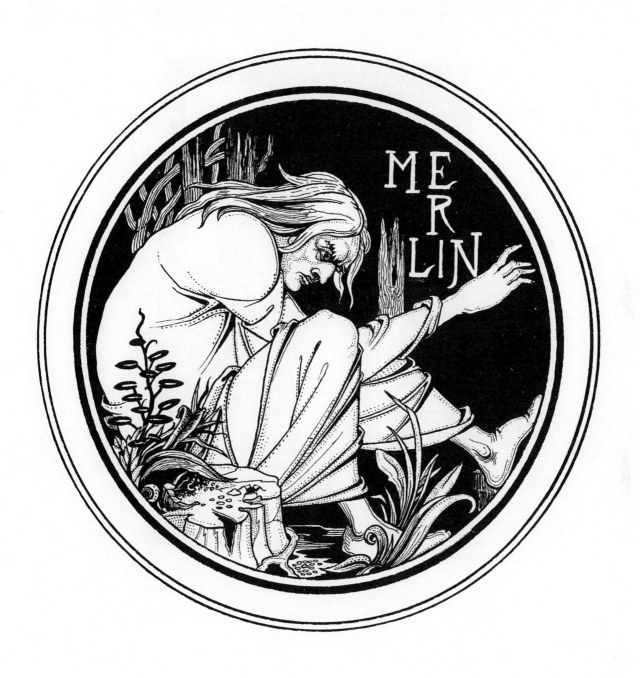

MERLIN. FROM "LE
MORTE D'ARTHUR"

Plate 67

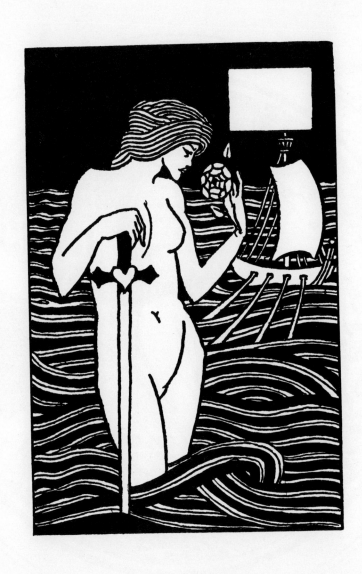

Plate 68

VIGNETTE. FROM " LE
MORTE D'ARTHUR " ⊠

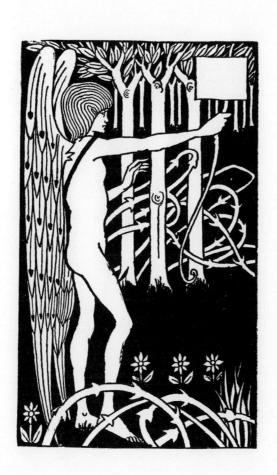

Plate 69

VIGNETTE. FROM " LE
MORTE D'ARTHUR "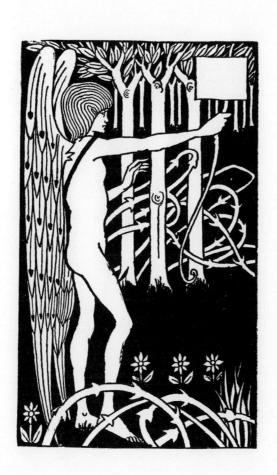

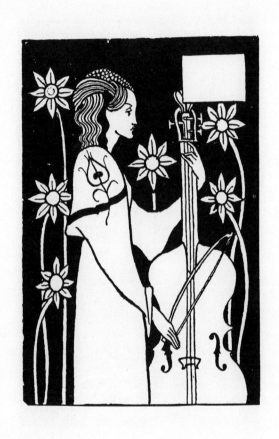

Plate 70

VIGNETTE. FROM " LE
MORTE D'ARTHUR

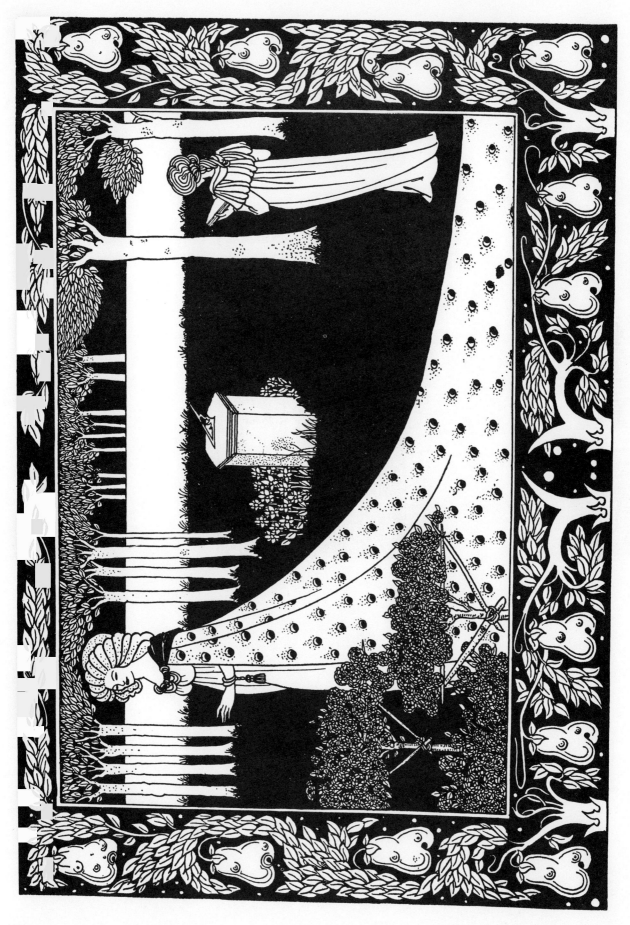

LA BEALE ISOUD AT JOYOUS GARD.
FROM "LE MORTE D'ARTHUR"

Plate 71

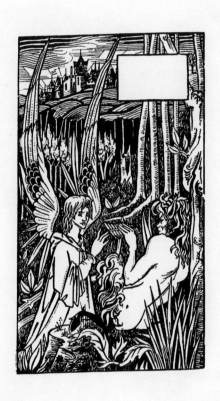

VIGNETTE. FROM " LE
MORTE D'ARTHUR " ⊠

Plate 72

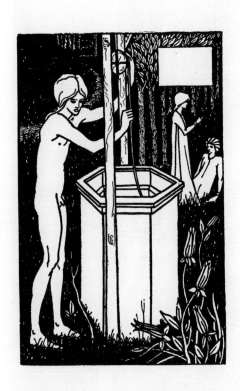

Plate 73

VIGNETTE. FROM " LE
MORTE D'ARTHUR "

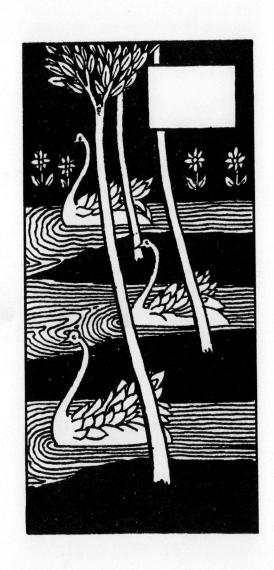

Plate 74

VIGNETTE. FROM " LE
MORTE D'ARTHUR "

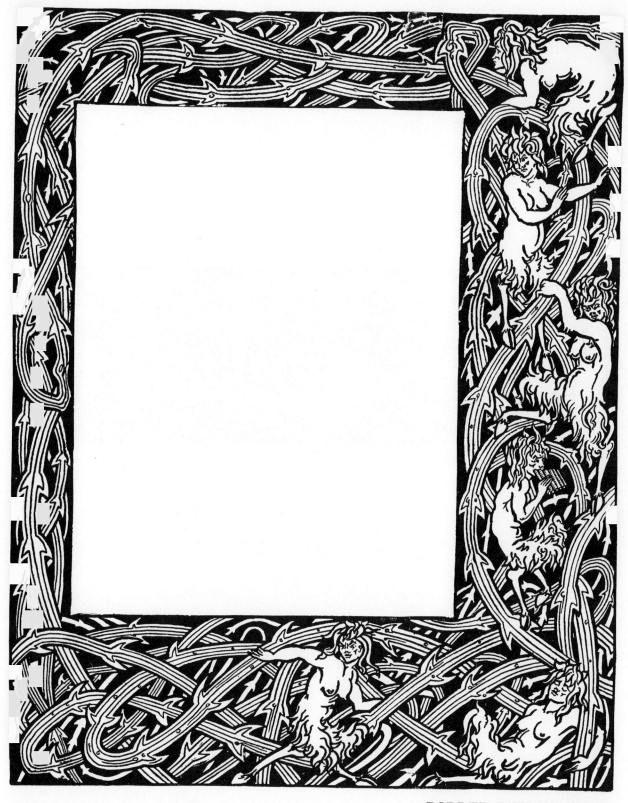

Plate 75

BORDER DESIGN. FROM
" LE MORTE D'ARTHUR "

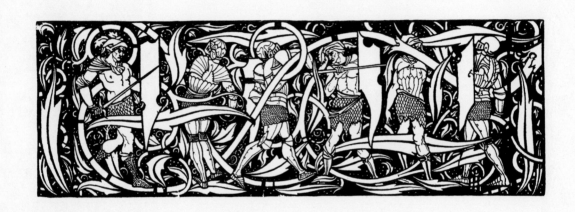

Plate 76

HEADPIECE. FROM " LE
MORTE D'ARTHUR " ⊠

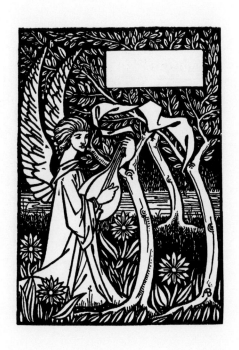

Plate 77

VIGNETTE. FROM "LE
MORTE D'ARTHUR" ⊗

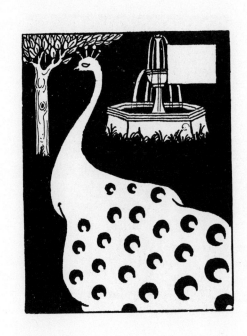

Plate 78

VIGNETTE. FROM " LE
MORTE D'ARTHUR " ✪

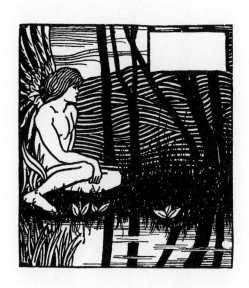

Plate 79

VIGNETTE. FROM " LE
MORTE D'ARTHUR "

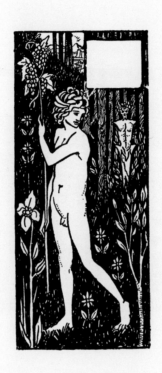

Plate 80

VIGNETTE.　FROM "LE
MORTE D'ARTHUR"

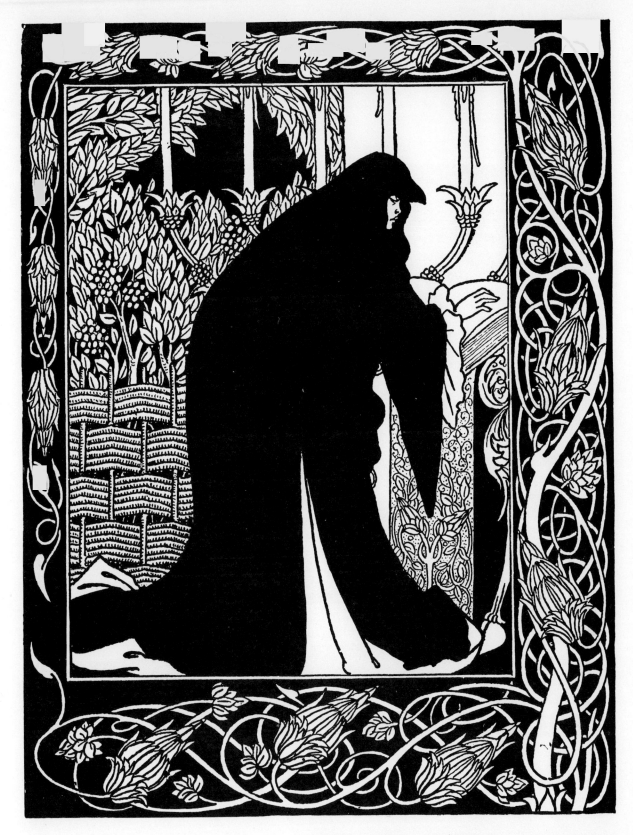

Plate 81

HOW QUEEN GUENEVER MADE HER A
NUN. FROM "LE MORTE D'ARTHUR"

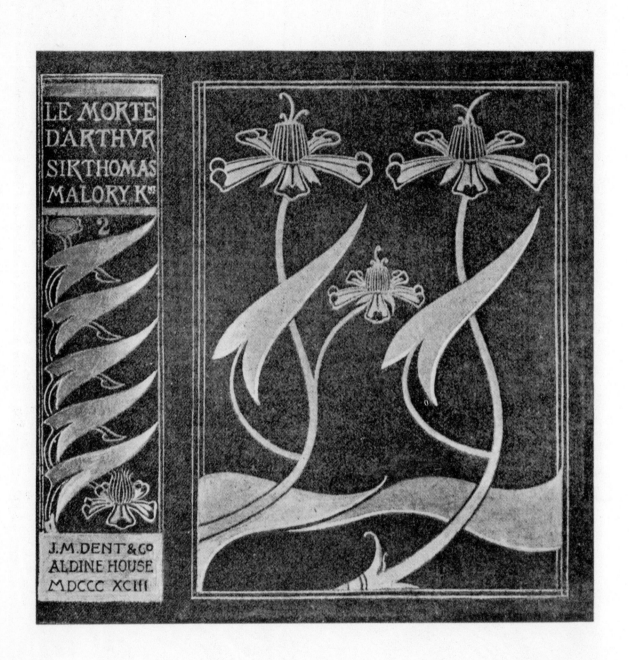

Plate 82

COVER DESIGN. FROM " LE
MORTE D'ARTHUR "

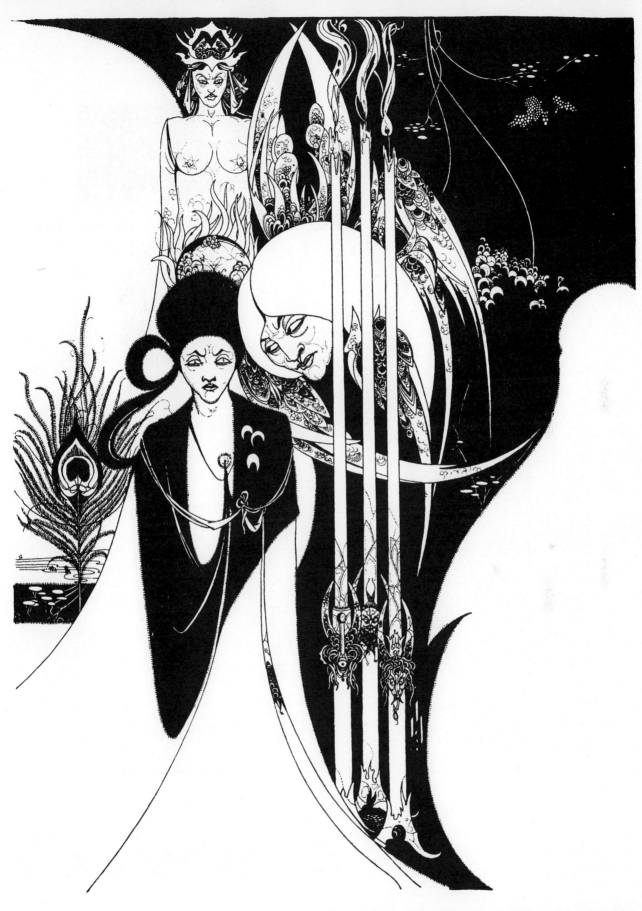

"OF A NEOPHYTE, AND HOW THE BLACK
ART WAS REVEALED UNTO HIM." BY
PERMISSION OF THE PROPRIETOR OF
"THE PALL MALL MAGAZINE" ⊠ ⊠

Plate 83

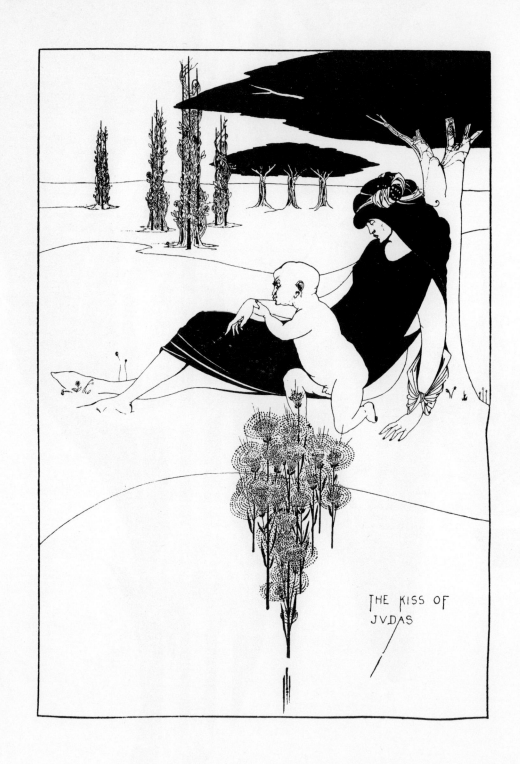

THE KISS OF
JVDAS

THE KISS OF JUDAS. BY PERMISSION
OF THE PROPRIETOR OF "THE PALL
MALL MAGAZINE" ⊠ ⊠ ⊠ ⊠

Plate 84

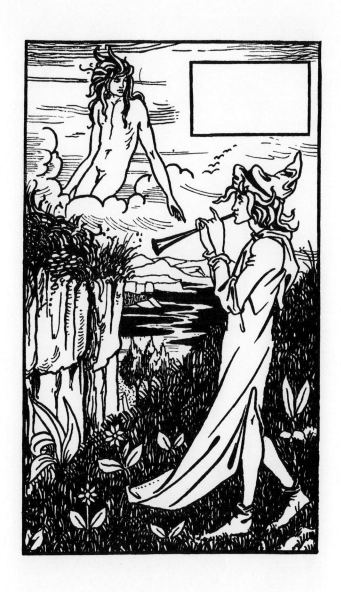

Plate 85

VIGNETTE. FROM "LE MORTE D'ARTHUR" ✠

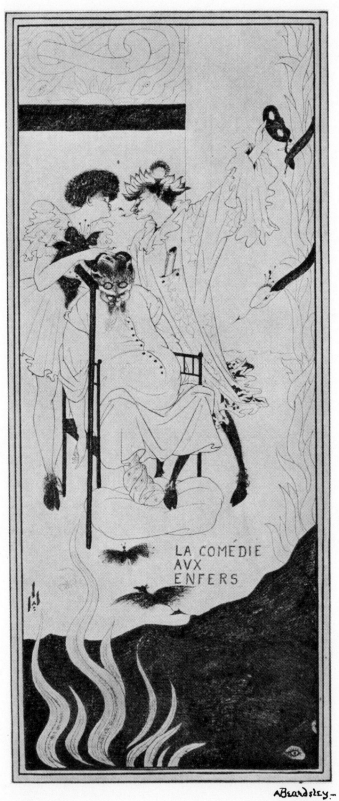

LA COMÉDIE
AVX
ENFERS

LA COMÉDIE AUX ENFERS.
BY PERMISSION OF MR.
JOSEPH PENNELL

Plate 86

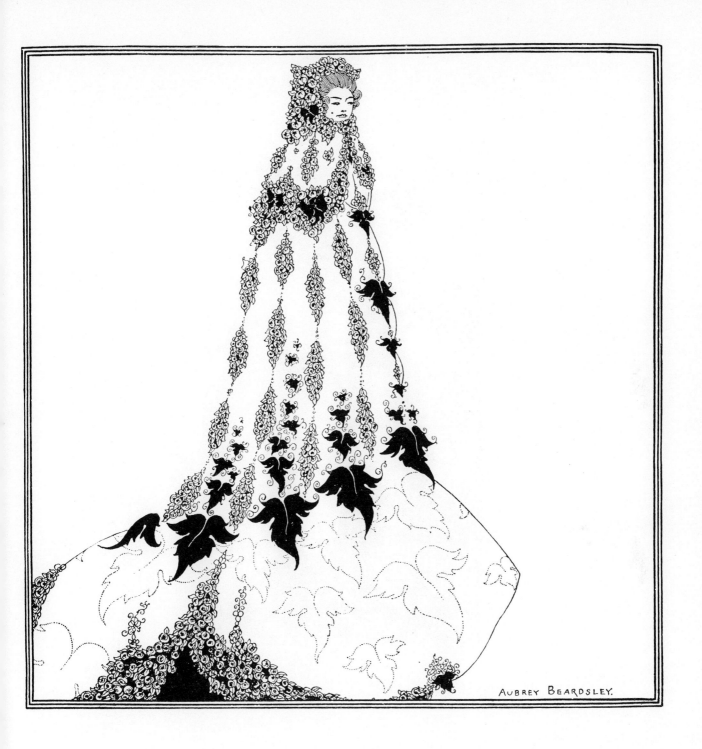

A SUGGESTED REFORM IN BALLET
COSTUME (UNFINISHED DRAWING).
REPRODUCED BY PERMISSION OF
MR. JOSEPH PENNELL

Plate 87

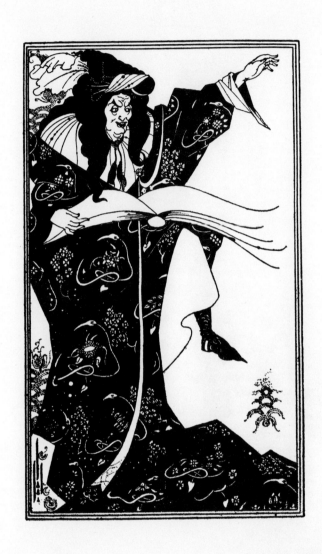

Plate 88

DESIGN FOR FRONTISPIECE TO
"VIRGILIUS THE SORCERER." BY
PERMISSION OF MR. DAVID NUTT

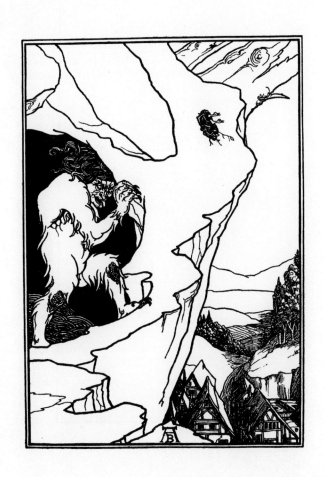

DESIGN FOR FRONTISPIECE OF
BJÖRNSON'S DRAMA "PASTOR
SANG." BY PERMISSION OF
MESSRS. LONGMANS, GREEN
AND CO. AND MR. ELKIN
MATHEWS ☒ ☒ ☒ ☒

Plate 89

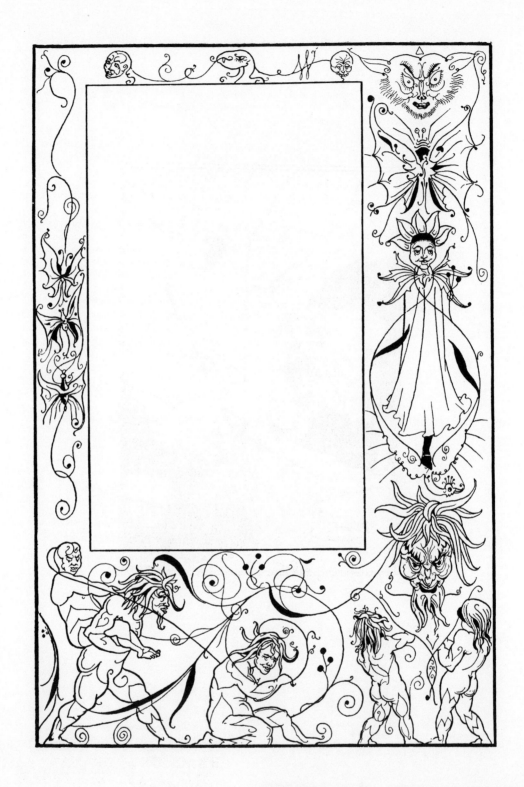

Plate 90

FRONTISPIECE. FROM " BON MOTS."
REPRODUCED BY PERMISSION OF
MESSRS. J. M. DENT AND CO.

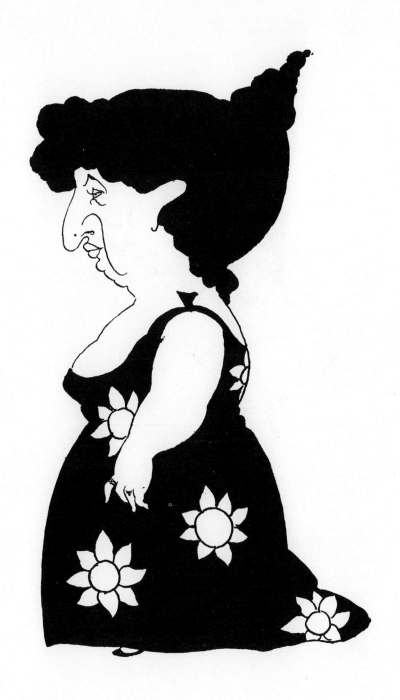

Plate 91

DESIGN. FROM "BON MOTS."
REPRODUCED BY PERMISSION
OF MESSRS. J. M. DENT AND CO.

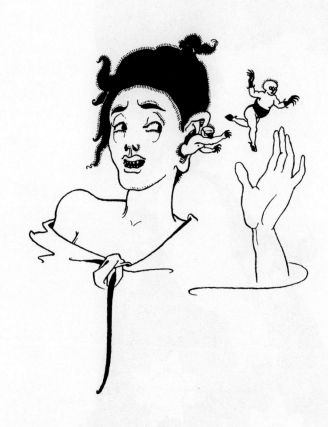

Plate 92

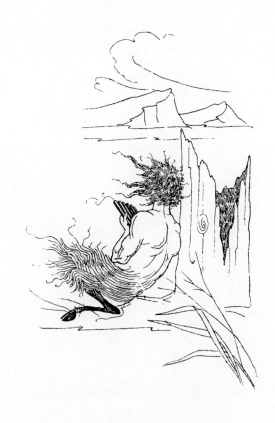

DESIGN. FROM " BON MOTS."
REPRODUCED BY PERMISSION
OF MESSRS. J. M. DENT AND CO.

Plate 93

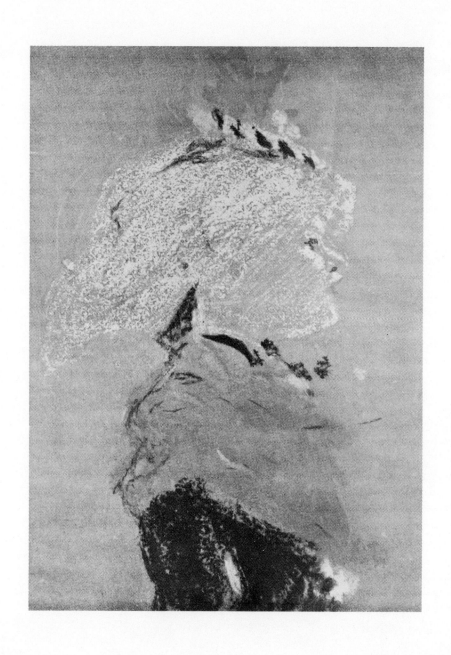

Plate 94

ADA LUNDBERG. BY PERMIS-
SION OF MR. JULIAN SAMPSON
*This plate also appears in color as the
frontispiece.*

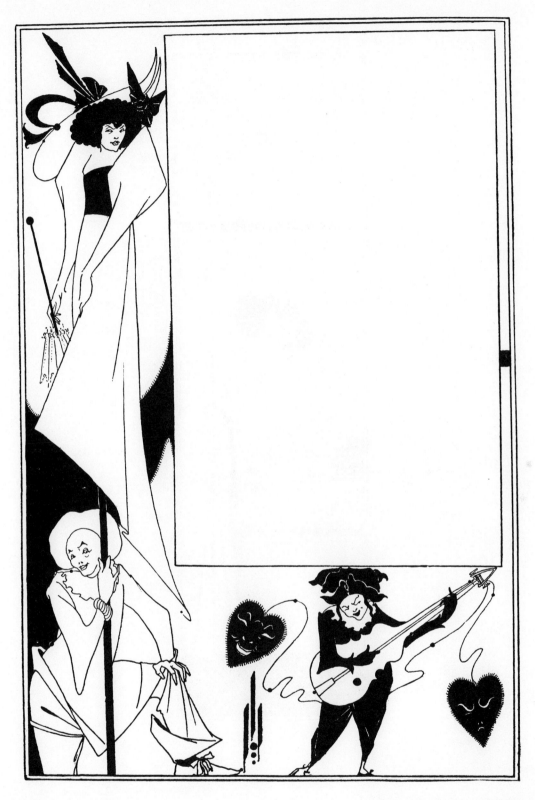

DESIGN FOR COVER OF
"KEYNOTES"

Plate 95

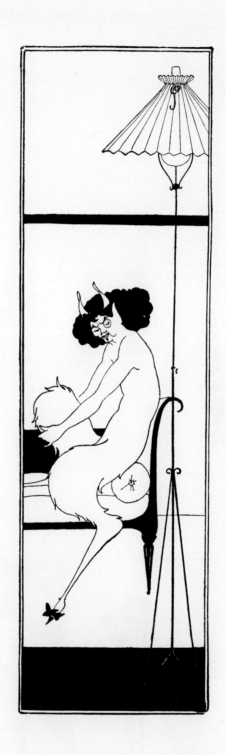

Plate 96

DESIGN FOR COVER OF
"THE DANCING FAUN"

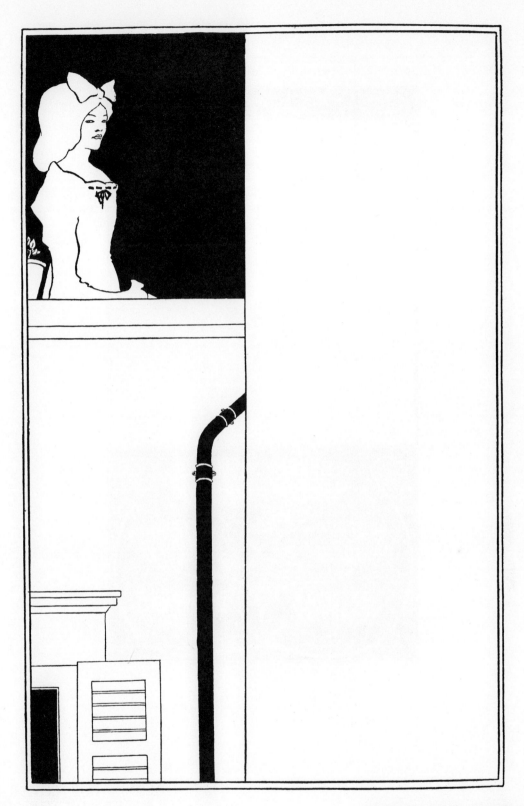

Plate 97

DESIGN FOR COVER OF
" POOR FOLK "

Plate 98

DESIGN FOR COVER OF
" A CHILD OF THE AGE "

Plate 101

DESIGN FOR COVER OF
" PRINCE ZALESKI "

Plate 102

DESIGN FOR COVER OF "THE
WOMAN WHO DID"

Plate 103

DESIGN FOR COVER OF
" WOMEN'S TRAGEDIES "

Plate 104

DESIGN FOR COVER OF
"GREY ROSES"

Plate 105

DESIGN FOR COVER OF
"AT THE FIRST CORNER"

DESIGN FOR COVER OF
" MONOCHROMES "

Plate 107

DESIGN FOR COVER OF "AT THE RELTON ARMS" ⊠ ⊠

Plate 108

DESIGN FOR COVER OF "THE
GIRL FROM THE FARM"

Plate 109

DESIGN FOR COVER OF "THE
MIRROR OF MUSIC" ✠ ✠

Plate 110

DESIGN FOR COVER OF
" YELLOW AND WHITE "

Plate 111

DESIGN FOR COVER OF " THE
MOUNTAIN LOVERS " � ✖

Plate 112

DESIGN FOR COVER OF " THE
WOMAN WHO DIDN'T "

Plate 113

DESIGN FOR COVER OF " THE
THREE IMPOSTORS " ✠ ✠

Plate 114

DESIGN FOR COVER OF
"NOBODY'S FAULT"

Plate 115

DESIGN FOR COVER OF " THE
BRITISH BARBARIANS "

Plate 116

DESIGN FOR COVER OF "THE
BARBAROUS BRITISHERS" ⊗

Plate 117

DESIGN FOR COVER OF " PLATONIC AFFECTIONS " ✪ ✪ ✪ ✪

Plate 118

DESIGN FOR COVER OF "YOUNG OFEG'S DITTIES" ⊠ ⊠ ⊠

Plate 119

DESIGN FOR TITLE-PAGE OF
"PAGAN PAPERS" ⊠ ⊠

Plate 120

UNFINISHED SKETCH FOR
"THE GREAT GOD PAN"

Plate 121

EIGHT INITIAL KEYS, FROM
BACKS OF " KEYNOTES " SERIES

Plate 122

SEVEN INITIAL KEYS, FROM
BACKS OF "KEYNOTES" SERIES

Plate 123

INITIAL KEY, DESIGNED
FOR CUTTING IN GOLD

Plate 124

DESIGN FOR COVER OF
" KEYNOTES CIRCULAR "

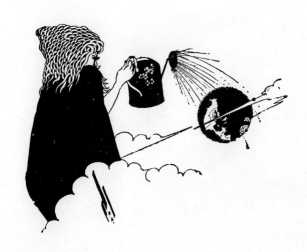

Plate 125

HEADPIECE. BY PERMISSION
OF MR. HENRY REICHARDT

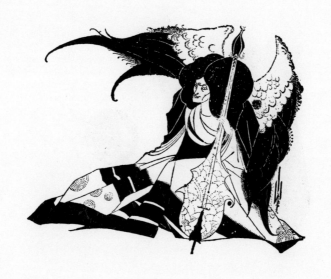

Plate 126

HEADPIECE. BY PERMISSION
OF MR. HENRY REICHARDT

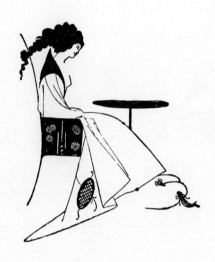

Plate 127

HEADPIECE. BY PERMISSION
OF MR. HENRY REICHARDT

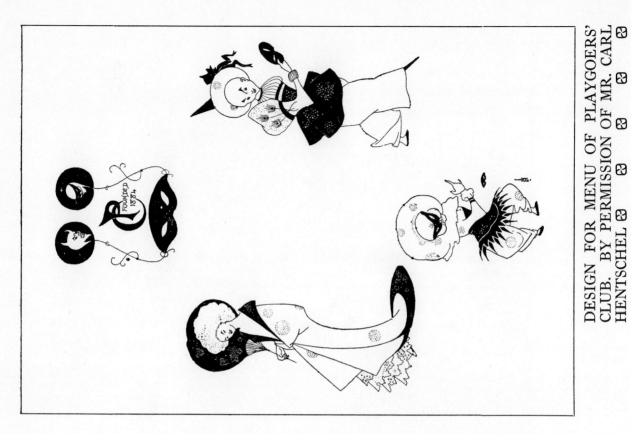

DESIGN FOR MENU OF PLAYGOERS'
CLUB. BY PERMISSION OF MR. CARL
HENTSCHEL

Plate 128

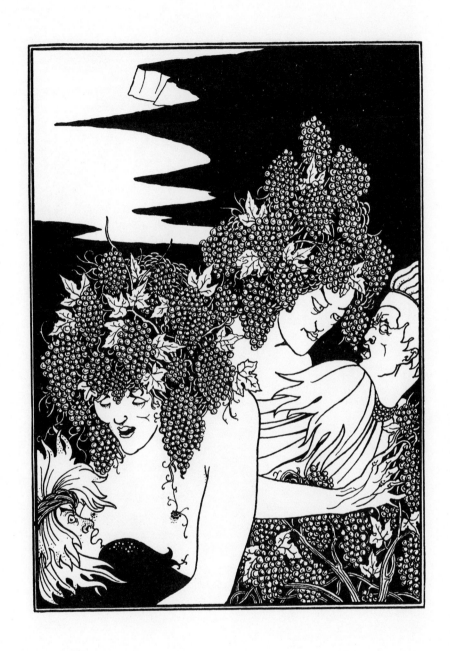

THE SNARE OF VINTAGE. FROM
" LUCIAN'S TRUE HISTORY." RE-
PRODUCED BY PERMISSION OF
MESSRS. LAWRENCE AND BULLEN

Plate 129

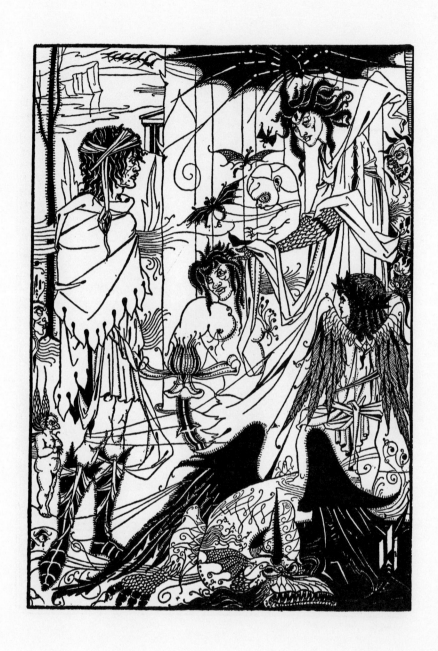

Plate 130

DREAMS. FROM "LUCIAN'S TRUE
HISTORY." REPRODUCED BY PER-
MISSION OF MESSRS. LAWRENCE
AND BULLEN ⊠　　⊠　　⊠　　⊠

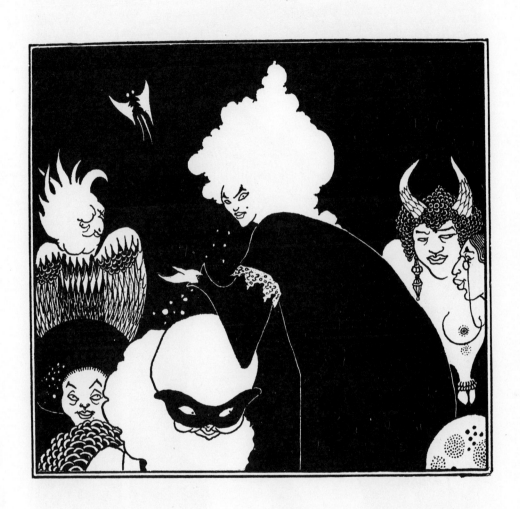

Plate 131

DESIGN. INTENDED FOR
"LUCIAN'S TRUE HISTORY,"
BUT NOT PUBLISHED

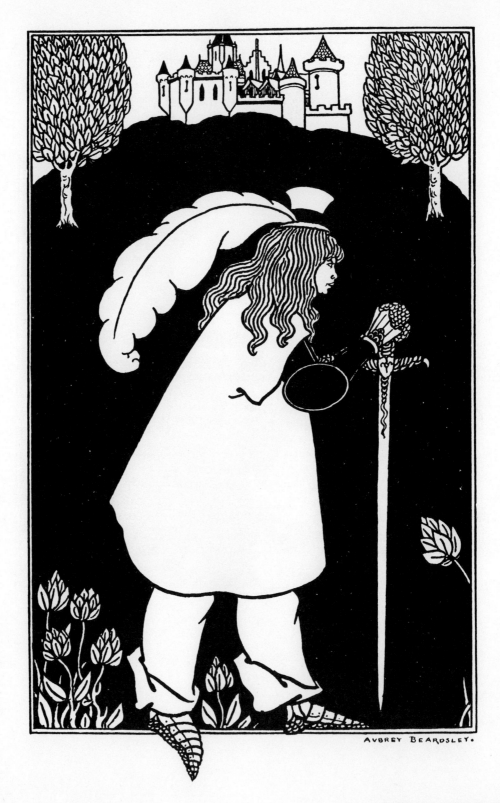

Plate 132

BARON VERDIGRIS

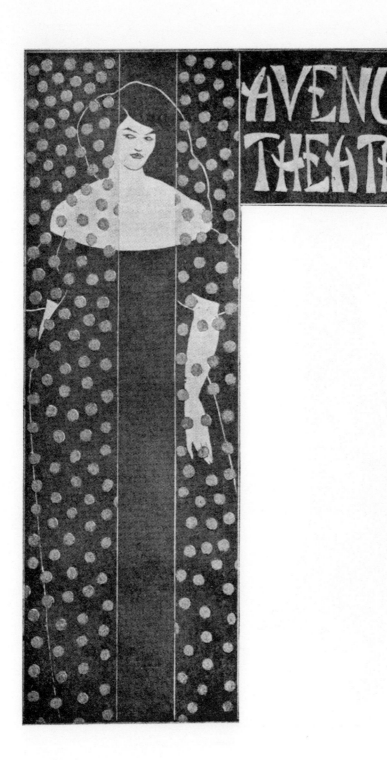

Plate 133

AVENUE THEATRE POSTER. FOR
" A COMEDY OF SIGHS "

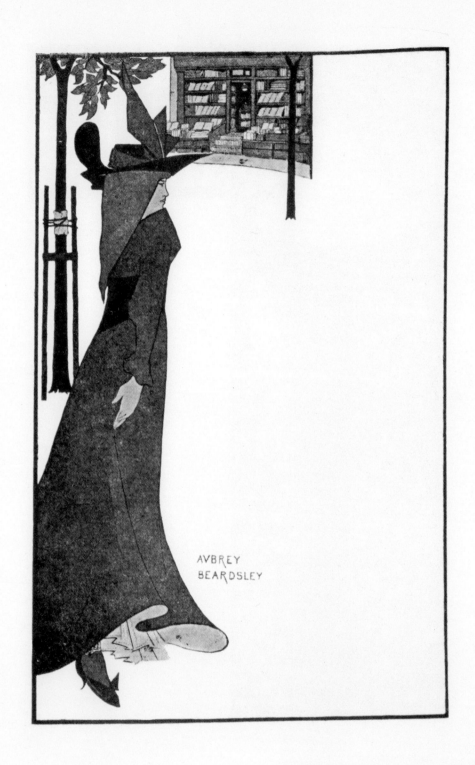

AVBREY
BEARDSLEY

Plate 134

"THE PSEUDONYM LIBRARY"
POSTER. REPRODUCED BY
PERMISSION OF MR. T. FISHER
UNWIN ⊠ ⊠ ⊠ ⊠

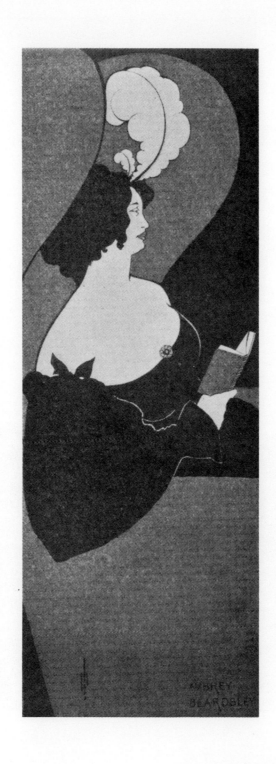

Plate 135

Plate 136

SKETCH PORTRAIT OF
HIMSELF

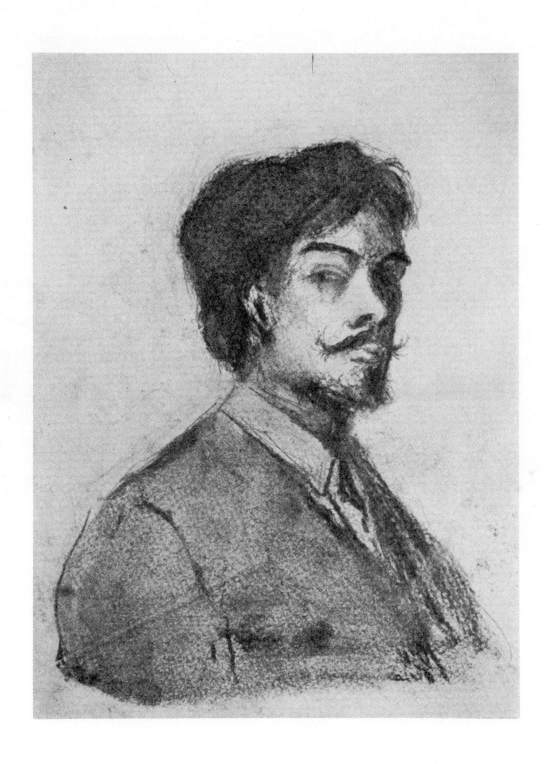

 *Plate* 137

SKETCH PORTRAIT OF
HENRY HARLAND

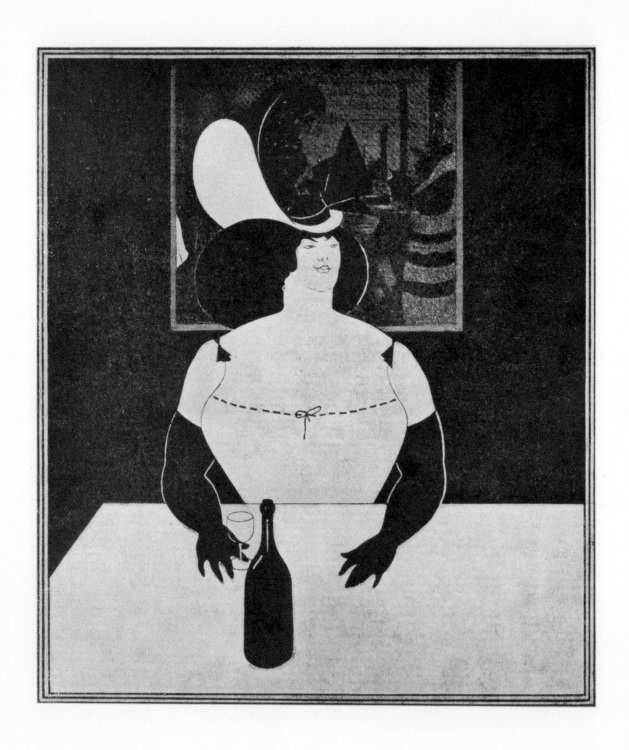

Plate 138

THE FAT WOMAN. REPRO-
DUCED BY PERMISSION OF
MRS. MARTINEAU

Plate 139

DESIGN FOR FRONT COVER
OF " SALOME " ⊠ ⊠ ⊠

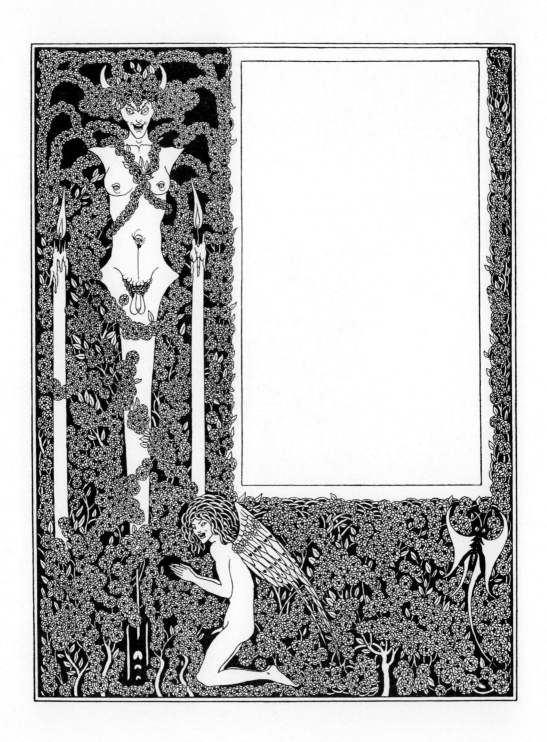

Plate 140

DESIGN FOR THE TITLE-
PAGE OF "SALOME"

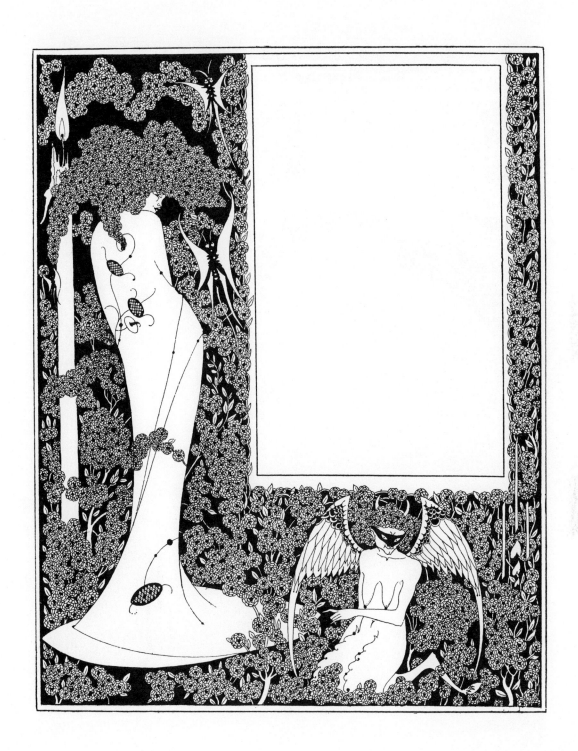

Plate 141

CONTENTS BORDER DESIGN.
FROM "SALOME"

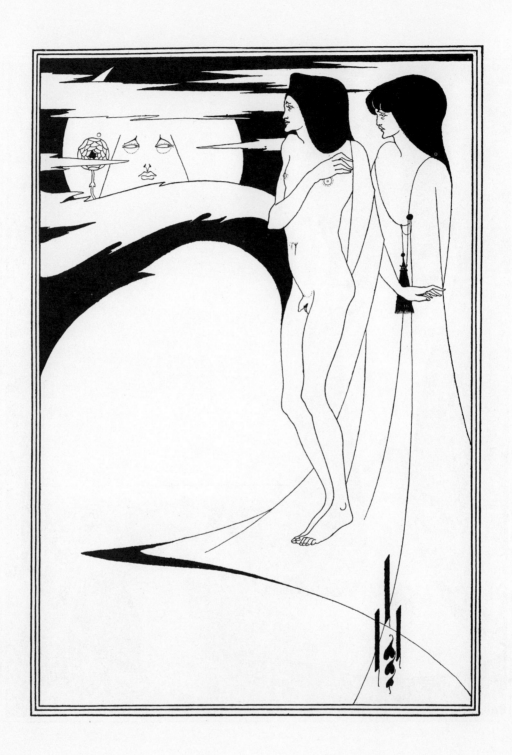

THE WOMAN IN THE MOON.
FROM " SALOME " ⊗ ⊗

Plate 142

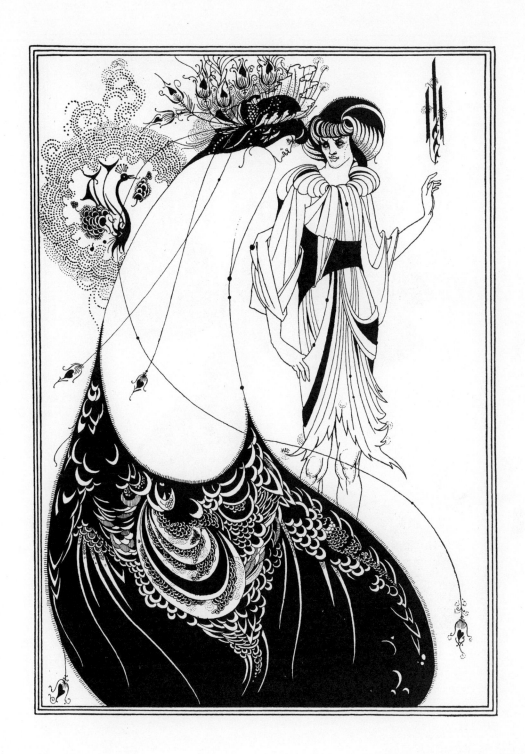

Plate 143

THE PEACOCK SKIRT.
FROM " SALOME "

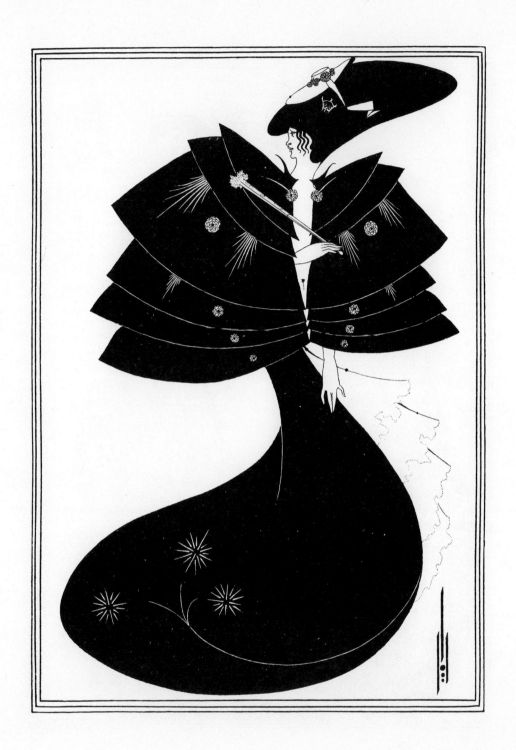

Plate 144

THE BLACK CAPE.
FROM "SALOME"

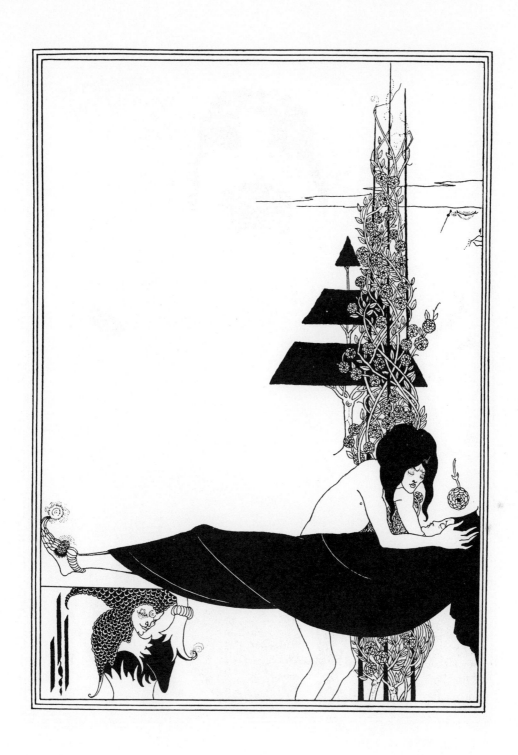

THE PLATONIC LAMENT.
FROM "SALOME"

Plate 145

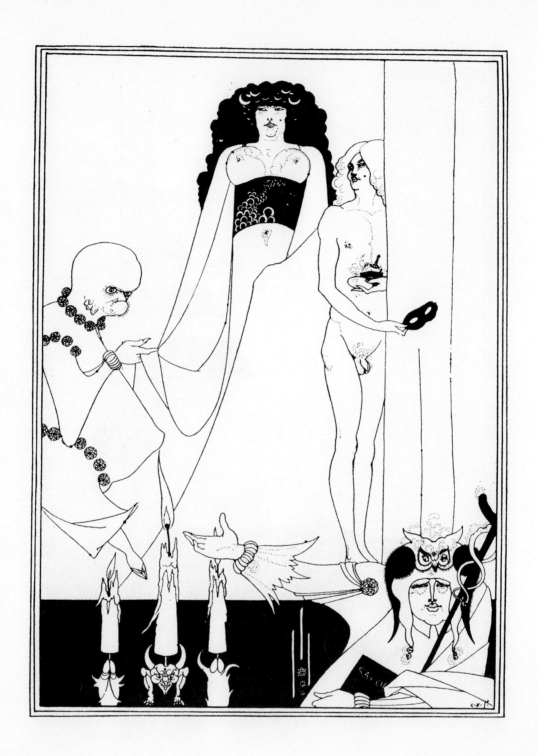

Plate 146

ENTER HERODIAS.
FROM " SALOME "

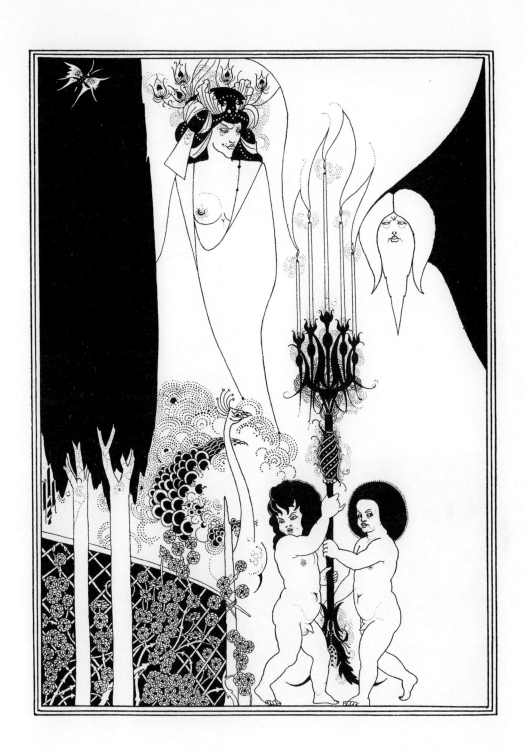

THE EYES OF HEROD.
FROM "SALOME"

Plate 147

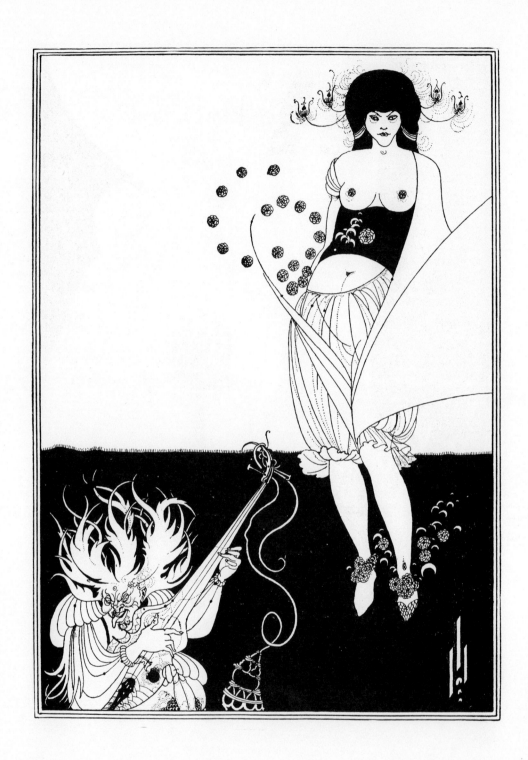

THE STOMACH DANCE.
FROM " SALOME "

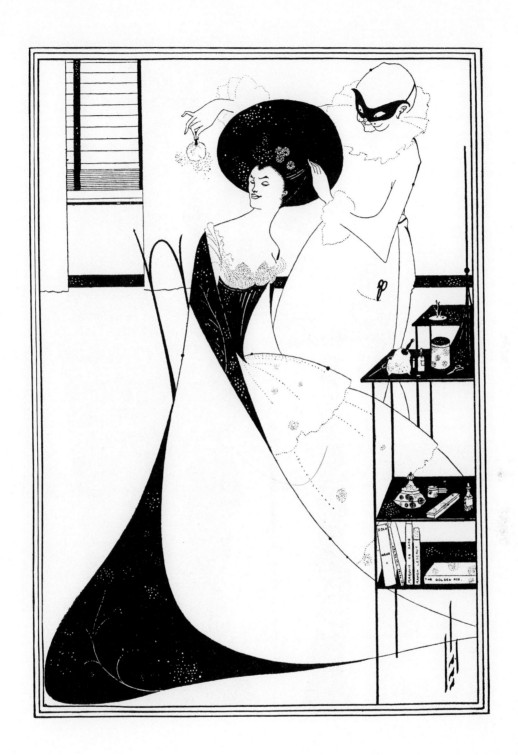

Plate 149

THE TOILETTE OF SALOME
FROM " SALOME "

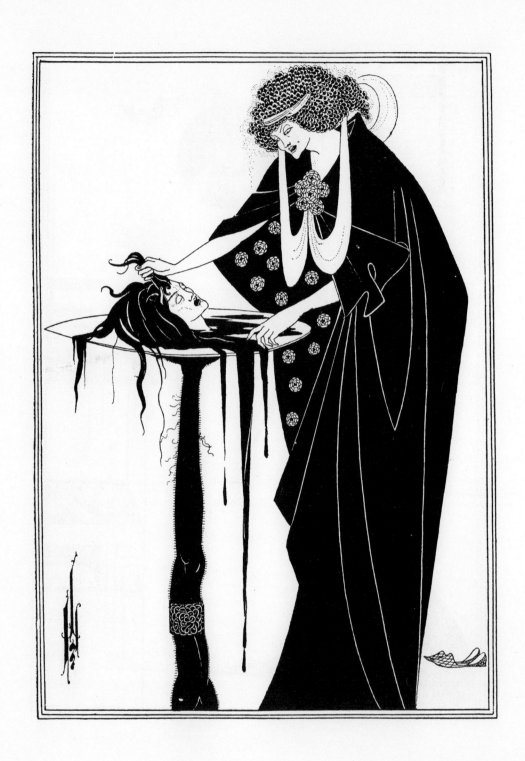

THE DANCER'S REWARD.
FROM "SALOME"

Plate 150

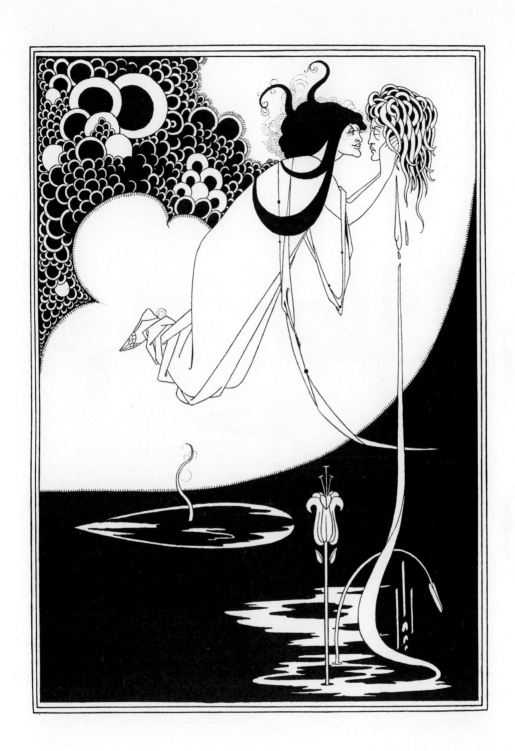

Plate 151

THE CLIMAX. FROM
" SALOME "

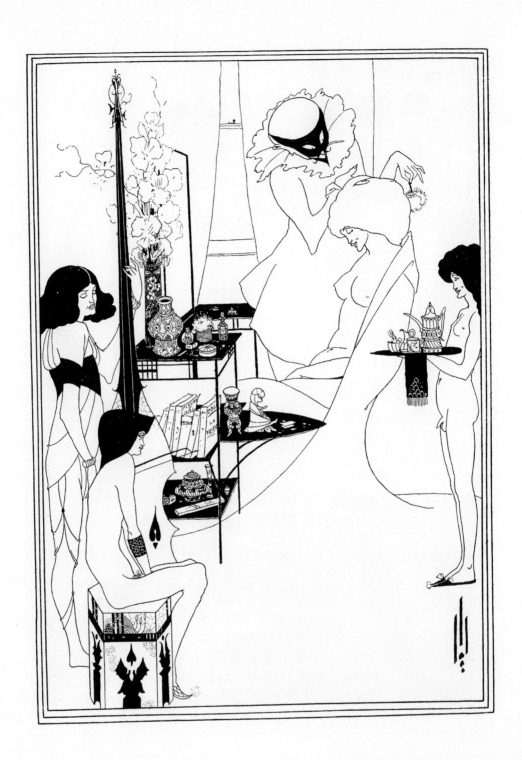

THE TOILETTE OF SALOME.
FIRST DRAWING. FROM
"SALOME" ⊠ ⊠ ⊠

Plate 152

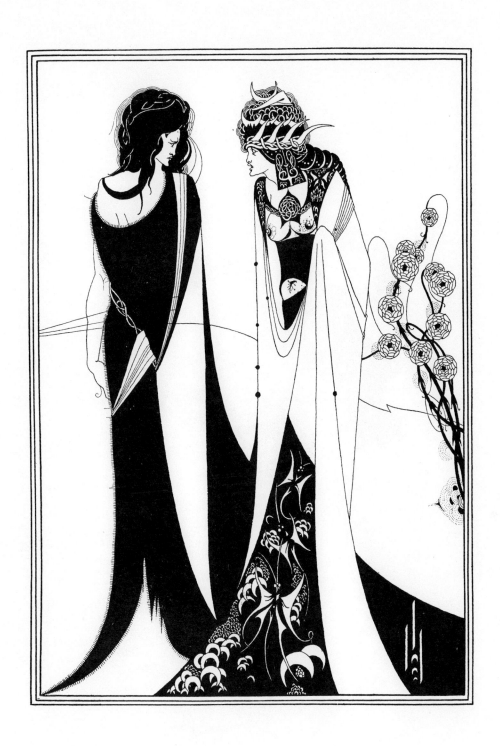

Plate 153

JOHN AND SALOME.
FROM " SALOME "

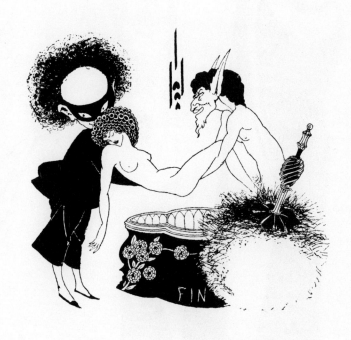

Plate 154

DESIGN FOR TAILPIECE.
FROM "SALOME"

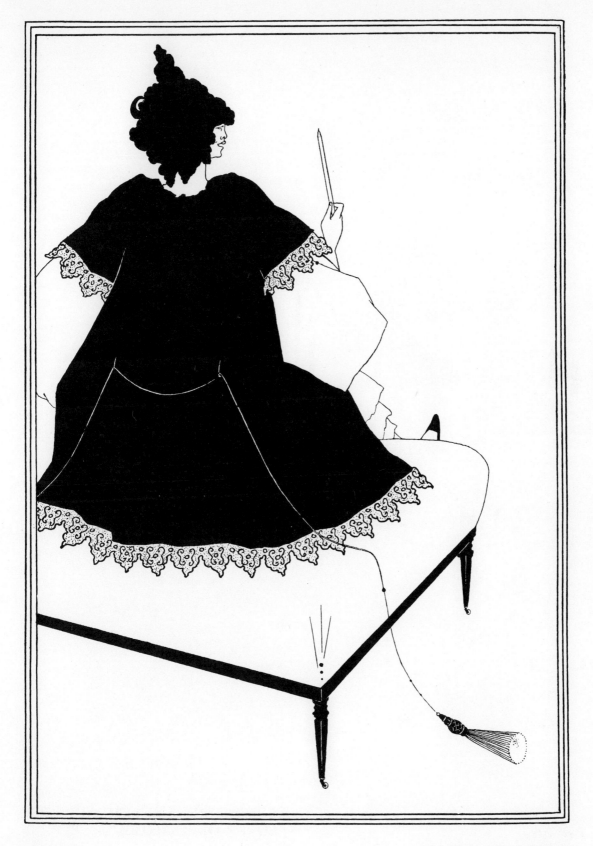

Plate 155

SALOME ON SETTLE

Plate 156

SIGNATURE, FROM THE REVERSE
COVER OF "SALOME"

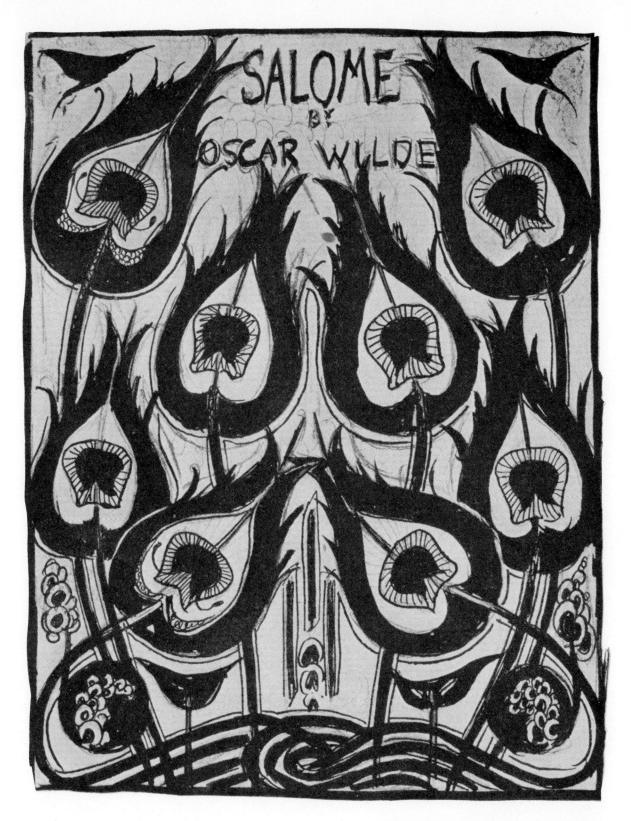

Plate 157

ORIGINAL SKETCH FOR THE
COVER OF "SALOME"

Dover Books on Art

AN ATLAS OF ANIMAL ANATOMY FOR ARTISTS, W. Ellen-berger, H. Baum, H. Dittrich. The largest, richest animal anatomy for artists in English. Form, musculature, tendons, bone structure, expression, detailed cross sections of head, other features, of the horse, lion, dog, cat, deer, seal, kangaroo, cow, bull, goat, monkey, hare, many other animals. "Highly recommended," DESIGN. Second, revised, enlarged edition with new plates from Cuvier, Stubbs, etc. 288 illustrations. 153pp. 11⅜ x 9.

20082-5 Paperbound $3.00

ANIMAL DRAWING: ANATOMY AND ACTION FOR ARTISTS, C. R. Knight. 158 studies, with full accompanying text, of such animals as the gorilla, bear, bison, dromedary, camel, vulture, pelican, iguana, shark, etc., by one of the greatest modern masters of animal drawing. Innumerable tips on how to get life expression into your work. "An excellent reference work," SAN FRANCISCO CHRONICLE. 158 illustrations. 156pp. 10½ x 8½.

20426-X Paperbound $3.00

ARCHITECTURAL AND PERSPECTIVE DESIGNS, Giuseppe Galli Bibiena. 50 imaginative scenic drawings of Giuseppe Galli Bibiena, principal theatrical engineer and architect to the Viennese court of Charles VI. Aside from its interest to art historians, students, and art lovers, there is a whole Baroque world of material in this book for the commercial artist. Portrait of Charles VI by Martin de Meytens. 1 allegorical plate. 50 additional plates. New introduction. vi + 103pp. 10⅛ x 13¼.

21263-7 Paperbound $2.50

HANDBOOK OF DESIGNS AND DEVICES, C. P. Hornung. A remarkable working collection of 1836 basic designs and variations, all copyright-free. Variations of circle, line, cross, diamond, swastika, star, scroll, shield, many more. Notes on symbolism. "A necessity to every designer who would be original without having to labor heavily," ARTIST AND ADVERTISER. 204 plates. 240pp. 5⅜ x 8. 20125-2 Paperbound $2.00

CHINESE HOUSEHOLD FURNITURE, G. N. Kates. A summary of virtually everything that is known about authentic Chinese furniture before it was contaminated by the influence of the West. The text covers history of styles, materials used, principles of design and craftsmanship, and furniture arrangement—all fully illustrated. xiii + 190pp. 5⅝ x 8½.

20958-X Paperbound $2.00

DECORATIVE ART OF THE SOUTHWESTERN INDIANS, D. S. Sides. 300 black and white reproductions from one of the most beautiful art traditions of the primitive world, ranging from the geometric art of the Great Pueblo period of the 13th century to modern folk art. Motives from basketry, beadwork, Zuni masks, Hopi kachina dolls, Navajo sand pictures and blankets, and ceramic ware. Unusual and imaginative designs will inspire craftsmen in all media, and commercial artists may reproduce any of them without permission or payment. xviii + 101pp. 5⅝ x 8⅜. 20139-2 Paperbound $1.50

GRAPHIC WORLDS OF PETER BRUEGEL THE ELDER,
H. A. Klein. 64 of the finest etchings and engravings made from
the drawings of the Flemish master Peter Bruegel. Every aspect
of the artist's diversified style and subject matter is represented,
with notes providing biographical and other background in-
formation. Excellent reproductions on opaque stock with nothing
on reverse side. 63 engravings, 1 woodcut. Bibliography. xviii +
289pp. 11⅜ x 8¼. 21132-0 Paperbound $4.00

THE COMPLETE WOODCUTS OF ALBRECHT DURER,
edited by Dr. Willi Kurth. Albrecht Dürer was a master in vari-
ous media, but it was in woodcut design that his creative genius
reached its highest expression. Here are all of his extant wood-
cuts, a collection of over 300 great works, many of which are
not available elsewhere. An indispensable work for the art his-
torian and critic and all art lovers. 346 plates. Index. 285pp.
8½ x 12¼. 21097-9 Paperbound $3.50

GRAPHIC REPRODUCTION IN PRINTING, H. Curwen. A
behind-the-scenes account of the various processes of graphic
reproduction—relief, intaglio, stenciling, lithography, line
methods, continuous tone methods, photogravure, collotype—
and the advantages and limitations of each. Invaluable for all
artists, advertising art directors, commercial designers, adver-
tisers, publishers, and all art lovers who buy prints as a hobby.
137 illustrations, including 13 full-page plates, 10 in color. xvi +
171pp. 5¼ x 8½. 20512-6 Clothbound $7.50

WILD FOWL DECOYS, Joel Barber. Antique dealers, collectors,
craftsmen, hunters, readers of Americana, etc. will find this the
only thorough and reliable guide on the market today to this
unique folk art. It contains the history, cultural significance, re-
gional design variations; unusual decoy lore; working plans for
constructing decoys; and loads of illustrations. 140 full-page
plates, 4 in color. 14 additional plates of drawings and plans by
the author. xxvii + 156pp. 7⅞ x 10¾. 20011-6 Paperbound $4.00

1800 WOODCUTS BY THOMAS BEWICK AND HIS SCHOOL.
This is the largest collection of first-rate pictorial woodcuts in
print—an indispensable part of the working library of every
commercial artist, art director, production designer, packaging
artist, craftsman, manufacturer, librarian, art collector, and
artist. And best of all, when you buy your copy of Bewick, you
buy the rights to reproduce individual illustrations—no permis-
sion needed, no acknowledgments, no clearance fees! Classified
index. Bibliography and sources. xiv + 246pp. 9 x 12.

20766-8 Paperbound $4.00

THE SCRIPT LETTER, Tommy Thompson. Prepared by a noted
authority, this is a thorough, straightforward course of instruc-
tion with advice on virtually every facet of the art of script
lettering. Also a brief history of lettering with examples from
early copy books and illustrations from present day advertising
and packaging. Copiously illustrated. Bibliography. 128pp.
6½ x 9⅛. 21311-0 Paperbound $1.25

VASARI ON TECHNIQUE, G. Vasari. Pupil of Michelangelo, outstanding biographer of Renaissance artists reveals technical methods of his day. Marble, bronze, fresco painting, mosaics, engraving, stained glass, rustic ware, etc. Only English translation, extensively annotated by G. Baldwin Brown. 18 plates. 342pp. 5⅜ x 8. 20717-X Paperbound $3.50

FOOT-HIGH LETTERS: A GUIDE TO LETTERING, M. Price. 28 15½ x 22½" plates, give classic Roman alphabet, one foot high per letter, plus 9 other 2" high letter forms for each letter. 16 page syllabus. Ideal for lettering classes, home study. 28 plates in box. 20238-9 $6.00

A HANDBOOK OF WEAVES, G. H. Oelsner. Most complete book of weaves, fully explained, differentiated, illustrated. Plain weaves, irregular, double-stitched, filling satins; derivative, basket, rib weaves; steep, broken, herringbone, twills, lace, tricot, many others. Translated, revised by S. S. Dale; supplement on analysis of weaves. Bible for all handweavers. 1875 illustrations. 410pp. 6⅛ x 9¼. 20209-7 Clothbound $7.50

JAPANESE HOMES AND THEIR SURROUNDINGS, E. S. Morse. Classic describes, analyses, illustrates all aspects of traditional Japanese home, from plan and structure to appointments, furniture, etc. Published in 1886, before Japanese architecture was contaminated by Western, this is strikingly modern in beautiful, functional approach to living. Indispensable to every architect, interior decorator, designer. 307 illustrations. Glossary. 410pp. 5⅝ x 8⅜. 20746-3 Paperbound $3.00

THE DRAWINGS OF HEINRICH KLEY. Uncut publication of long-sought-after sketchbooks of satiric, ironic iconoclast. Remarkable fantasy, weird symbolism, brilliant technique make Kley a shocking experience to layman, endless source of ideas, techniques for artist. 200 drawings, original size, captions translated. Introduction. 136pp. 6 x 9. 20024-8 Paperbound $2.00

COSTUMES OF THE ANCIENTS, Thomas Hope. Beautiful, clear, sharp line drawings of Greek and Roman figures in full costume, by noted artist and antiquary of early 19th century. Dress, armor, divinities, masks, etc. Invaluable sourcebook for costumers, designers, first-rate picture file for illustrators, commercial artists. Introductory text by Hope. 300 plates. 6 x 9.
20021-3 Paperbound $2.50

EPOCHS OF CHINESE AND JAPANESE ART, E. Fenollosa. Classic study of pre-20th century Oriental art, revealing, as does no other book, the important interrelationships between the art of China and Japan and their history and sociology. Illustrations include ancient bronzes, Buddhist paintings by Kobo Daishi, scroll paintings by Toba Sojo, prints by Nobusane, screens by Korin, woodcuts by Hokusai, Koryusai, Utamaro, Hiroshige and scores of other pieces by Chinese and Japanese masters. Biographical preface. Notes. Index. 242 illustrations. Total of lii + 439pp. plus 174 plates. 5⅝ x 8¼.
20364-6, 20265-4 Two-volume set, Paperbound $5.90

LANDSCAPE GARDENING IN JAPAN, Josiah Conder. A detailed picture of Japanese gardening techniques and ideas, the artistic principles incorporated in the Japanese garden, and the religious and ethical concepts at the heart of those principles. Preface. 92 illustrations, plus all 40 full-page plates from the Supplement. Index. xv + 299pp. 8⅜ x 11¼.

21216-5 Paperbound $3.50

DESIGN AND FIGURE CARVING, E. J. Tangerman. "Anyone who can peel a potato can carve," states the author, and in this unusual book he shows you how, covering every stage in detail from very simple exercises working up to museum-quality pieces. Terrific aid for hobbyists, arts and crafts counselors, teachers, those who wish to make reproductions for the commercial market. Appendix: How to Enlarge a Design. Brief bibliography. Index. 1298 figures. x + 289pp. 5⅜ x 8½.

21209-2 Paperbound $2.00

THE STANDARD BOOK OF QUILT MAKING AND COLLECTING, M. Ickis. Even if you are a beginner, you will soon find yourself quilting like an expert, by following these clearly drawn patterns, photographs, and step-by-step instructions. Learn how to plan the quilt, to select the pattern to harmonize with the design and color of the room, to choose materials. Over 40 full-size patterns. Index. 483 illustrations. One color plate. xi + 276pp. 6¾ x 9½. 20582-7 Paperbound $2.50

LOST EXAMPLES OF COLONIAL ARCHITECTURE, J. M. Howells. This book offers a unique guided tour through America's architectural past, all of which is either no longer in existence or so changed that its original beauty has been destroyed. More than 275 clear photos of old churches, dwelling houses, public buildings, business structures, etc. 245 plates, containing 281 photos and 9 drawings, floorplans, etc. New Index. xvii + 248pp. 7⅞ x 10¾. 21143-6 Paperbound $3.00

A HISTORY OF COSTUME, Carl Köhler. The most reliable and authentic account of the development of dress from ancient times through the 19th century. Based on actual pieces of clothing that have survived, using paintings, statues and other reproductions only where originals no longer exist. Hundreds of illustrations, including detailed patterns for many articles. Highly useful for theatre and movie directors, fashion designers, illustrators, teachers. Edited and augmented by Emma von Sichart. Translated by Alexander K. Dallas. 594 illustrations. 464pp. 5⅛ x 7⅛.

21030-8 Paperbound $3.00

Dover publishes books on commercial art, art history, crafts, design, art classics; also books on music, literature, science, mathematics, puzzles and entertainments, chess, engineering, biology, philosophy, psychology, languages, history, and other fields. For free circulars write to Dept. DA, Dover Publications, Inc., 180 Varick St., New York, N.Y. 10014.